RICK
SAMMON'S

Digital Imaging
Workshops

BOOKS BY RICK SAMMON

Rick Sammon's Complete Guide to Digital Photography

Flying Flowers

Secrets of the Coral Reefs

Rick Sammon's Travel and Nature Photography

INSTRUCTIONAL CD-ROMS BY RICK SAMMON

Photoshop® CS for the Outdoor & Travel Photographer

Photoshop® CS Makeovers

RICK SAMMON'S

Digital Imaging Workshops

W. W. NORTON & COMPANY
NEW YORK • LONDON

Copyright © 2005 by Rick Sammon

Printed in the United States of America
First Edition

Manufacturing by R. R. Donnelley, Willard Division
Book design by Rubina Yeh
Production manager: Julia Druskin

Library of Congress Cataloging-in-Publication Data

Sammon, Rick.
 Rick Sammon's digital imaging workshops.—1st ed.
 p. cm.
 Includes bibliographical references and index.
 ISBN 0-393-32668-3 (pbk.)
1. Photography—Digital techniques—Handbooks, manuals, etc. 2. Image processing—
Digital techniques—Handbooks, manuals, etc. I. Title: Digital imaging workshops. II. Title.
 TR267.S265 2005
 775—dc22

2005005617

W. W. Norton & Company, Inc., 500 Fifth Avenue, New York, N.Y. 10110
www.wwnorton.com

W. W. Norton & Company Ltd., Castle House, 75/76 Wells Street, London W1T 3QT

1 2 3 4 5 6 7 8 9 0

For Julieanne
Thanks for inspiring so many of us

In fond memory of Dean Collins
Photographer, artist, teacher, mentor, and friend to all

Contents

PART III: THE DIGITAL IMAGING WORKSHOPS

PART IV: WORKSHOP EXTRAS

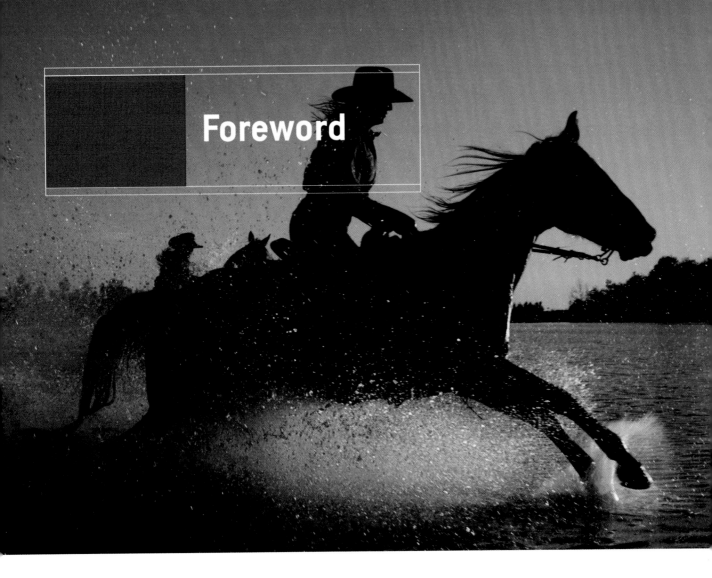

Foreword

What can you say about Rick Sammon? He's tall, likes flowered Hawaiian shirts, loves his family, and he is a good friend of mine. I'd recommend his book to anyone, if for no other reason than that he is a really good guy.

But I don't need to, because, of course, he is one of the best photographer-teachers around. I say that from the perspective of one who keeps close tabs on the industry as an author and photographer. Rick loves photography, loves the whole digital world related to photography, and he absolutely loves to tell everybody about it. You should see him at family gatherings—instead of telling ghost stories around the campfire, he's giving digital demonstrations at sunset.

Well, not really. But he could. The neat thing about Rick's work and enthusiasm for digital is that he

knows how to put what he knows into words and pictures that everyone can enjoy. This is a rare talent among photographers. Photographers, after all, are primarily visual people, and many of them have difficulty communicating their craft. There are even some fearful photographer-types who won't tell their "secrets" because they think that they will lose business or, at the very least, be unmasked as the man behind the curtain. Rick is no secretive pro. He wants everyone to enjoy digital photography and get the same fun and excitement he does from it.

Rick always seems to be having a lot of fun doing this work. I believe it shows on these pages. You want to try his techniques, not just because they look interesting but because Rick makes them sound and look like fun things to do. He has an easy, friendly

writing style that eases the reader into technical discussions before they even know it. And they learn.

Rick is also a fine photographer, traveling to find images that express and share his love of the world. From underwater scenes in the South Pacific and street vendors in India to the jungles of Belize, architecture in Venice, and cowboys in the American West, Rick loves to capture the world and bring it to everyone.

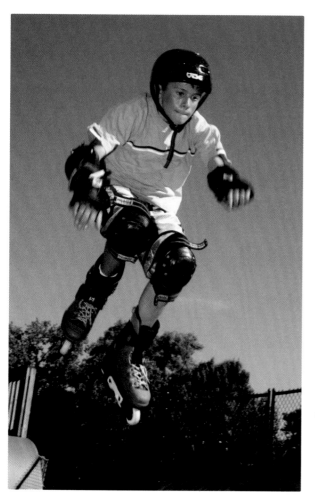

As editor of *Outdoor Photographer* and *PCPhoto* magazines, I love being able to see what new areas he has explored, what new visions he brings back to share.

Many people, even sophisticated photographers, don't understand how much a camera can influence what a photograph looks like. An image straight from the camera is rarely an accurate reflection of what the photographer saw, but more often only a direct capture of what the camera is capable of seeing. The two are not the same, and the camera's view is not always accurate. Rick brings his vision to that camera view, prodding and tweaking the photo until it better shows the world he has seen.

And the very neat thing is that Rick is always willing to share how he did that. He has enough confidence in his work that he doesn't worry if someone else learns his secrets. He does this in part because of his love of teaching, but I think there is something deeper. He loves what is beautiful in the world and realizes that he can only photograph and share so much. If other photographers get excited about what they can do with their photography, then they can share their own visions. That can make the whole world more visible, more present for all of us. In a sense, this is Rick's way of promoting world peace. If more people enjoy the world and its peoples through photography, then perhaps they will also want to protect and care for the world.

So saddle up for a great ride through Rick's latest book. If you pay attention and try out his tips, I guarantee you are in for a lot of fun and excitement.

Rob Sheppard
Editor, *Outdoor Photographer* and *PCPhoto* magazines
Group Editorial Director, Photo Magazine Group

RICK SAMMON'S

Digital Imaging Workshops

PART I Before We Begin

What Can We Do with Digital Imaging?

Awaken the Artist Within

Imagine what you can do with your original digital images. This sequence offers just a glimpse of the options when we edit.

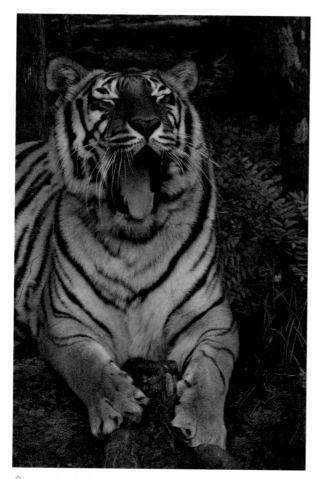

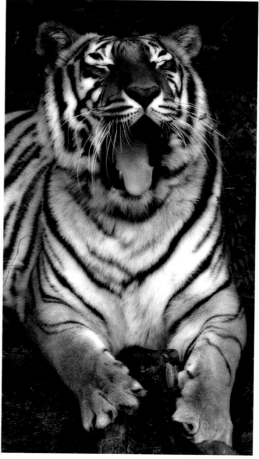

⇑ **Original picture.** It's a bit dull due to intentional underexposure to avoid highlights on the tiger's fur being washed out

⇑ **Traditional enhancement.** Look how the image is improved with a bit of cropping and a boost in color, contrast, and sharpness and burning (darkening) of the edges of the frame.

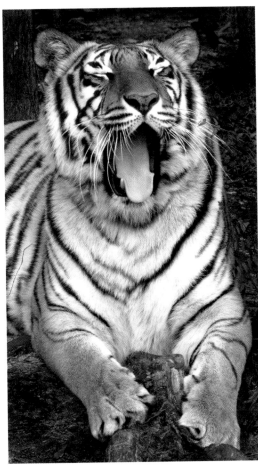

⇑ **Creative Elements enhancement.** See what happens when you remove the color from the scene and transform an image into a black-and-white photograph.

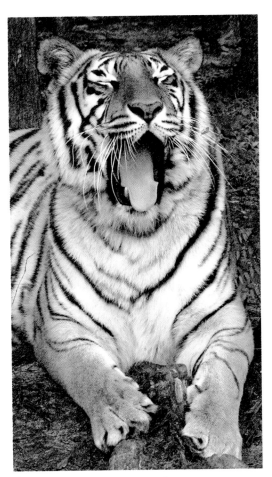

⇑ **Use a filter.** Apply the Elements Graphic Pen filter to the image for a more subtle effect.

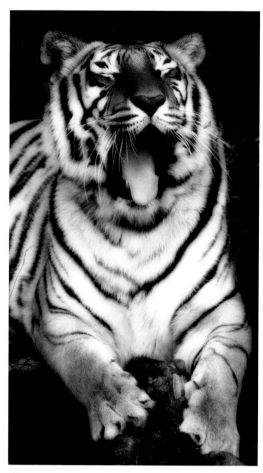

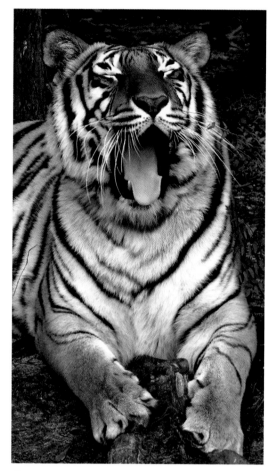

⇑ **Plug in to creativity.** Create the impression that a daytime picture was taken during the night by applying the Midnight Filter from nik multimedia, one of the many digital filters in a Photoshop Plug-in called Color Efex Pro 2.0.

⇑ **More Photoshop fun and options.** Tone a series of pictures for an exhibit or portfolio by using the Paper Toner Filter, a Plug-in from nik, also in Color Efex Pro.

Whenever I give a photography presentation, I begin by saying, "Every picture I've ever taken and every picture I will take can be enhanced in the digital darkroom." The same is true for every image you take. Digital image editing is simply altering a picture on a computer.

- We can transform dull and drab shots into images that pop with color;
- We can lighten and darken select areas of a picture;
- We can sharpen a picture, and we can soften it for a more subtle effect;
- We can professionally retouch our images, and do face and body makeovers, with a few careful clicks of a mouse;

- We can add action to still pictures, a feat that is possible in-camera but which is easier to accomplish on our computers, and can be done more reliably that way;
- We can level the horizon line if it's tilted;
- Color pictures can be transformed into dramatic black-and-white pictures, as well as hand-colored images;
- We can easily remove distracting and unwanted elements from a scene;
- We can crop and resize an image to fit whatever medium we will use to display it: inkjet print, Web site, and so on.

On the pages of this book, we will see the power of a digital image-editing program, specifically Adobe Photoshop Elements. I used Adobe Photoshop Elements to create all of the end-result pictures you will see. Most important, you'll learn how to transform your pictures into more creative and dramatic images, perhaps even works of art.

I do use Adobe Photoshop CS ("CS" stands for "creative suite," which is also known as Photoshop 8), a full-featured, digital image-editing program that costs several hundred dollars more than Elements. But as you'll see, some of the features of Photoshop CS that are not included in Elements can be replicated in Elements with a few extra steps. While writing this book, I was surprised to learn and experience the power of Elements.

If you are brand-new to digital image editing, you will find a whole new world of creativity at your fingertips. If you have some digital darkroom experience, you may find some new ideas on these pages.

It's true what I said about "every picture" at the beginning of this short homily. Please keep in mind, however, that it all starts in-camera. Sure, we can fix our mistakes and turn snapshots into art shots, but, as photographers, we need to do everything we can to get the best possible image when we snap the shutter release button.

Shutter speed, aperture, lens, shooting mode, ISO setting (digital image sensor sensitivity, usually from 100 to 1600 in digital SLRs), image quality (e.g., JPEG, RAW) setting, lens selection, lighting, and other factors all play a key role in capturing the image. We will cover some basic photography tips in the next lesson.

For detailed lessons on getting the best image when you press the shutter, you may want to browse through another one of my books, *Rick Sammon's Complete Guide to Digital Photography*.

Start in Your Camera

Top Tips for Taking Better Photographs

I hope you will enjoy the ideas in this book. Photoshop Elements, and other digital image programs, certainly open up a new world of creativity, and they allow us to correct some common photographic mistakes. We still need to think about the basics of photography before we press the shutter release button on our cameras. While any image can be modified in the digital darkroom, starting with a great photograph is best.

So, before we get into the digital editing part of this book, I'd like to share my top tips for capturing good images with your camera, at the moment our photographic experience really starts.

⇒ **Accent on aperture.** Compare these two pictures. One has the focus set on the foreground statue and the other has the focus set on the background statue. Which one do your prefer? When looking through the viewfinder of your auto focus camera, it's up to you to set the focus point (possible with most cameras via their focus lock feature).

⇑ **Avoid disappointment.** Our eyes can see a much greater dynamic range than any consumer digital sensor image in any camera. If we remember that, we can avoid disappointment when photographing subjects in tricky lighting conditions, such as when a subject is strongly backlit, which often requires the use of a flash.

⇑ **Be on the lookout.** Always be looking for unique photographic possibilities. Of course we can "awaken the artist within" in the digital darkroom by using software such as Photoshop Elements, but taking an artistic picture is also rewarding and satisfying.

⇒ **Be prepared.** This may sound like a simple tip, but if you are always prepared to take pictures—with a fully charged battery, plenty of free space on a memory card, and easy access to your camera and accessories—you may not miss great photo opportunities. Being ever-ready helped me get this wildlife shot in my backyard.

⇒ **Compose carefully.** Placing a subject in the center of the frame can be boring; hence the saying, "Dead center is deadly." An interesting composition technique is to imagine a tic-tac-toe grid over the scene, and then place the main subject where any two of the lines intersect.

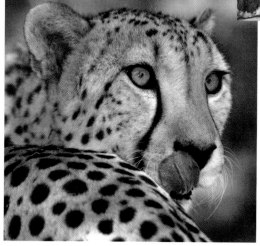

⇐ **The eyes have it.** In wildlife and portrait photography, your subject's eyes should be in focus and well lit. If the eyes are not naturally lit, use a flash or reflector to lighten them.

⇊ **Have it both ways.** When photographing people, take traditional portraits (head shots) as well as environmental portraits (pictures of a subject in his or her environment). Both types of portraits are effective, and each type tells a different story.

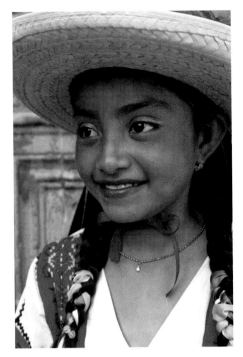 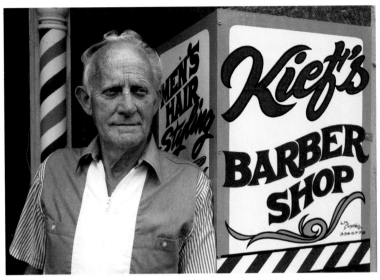

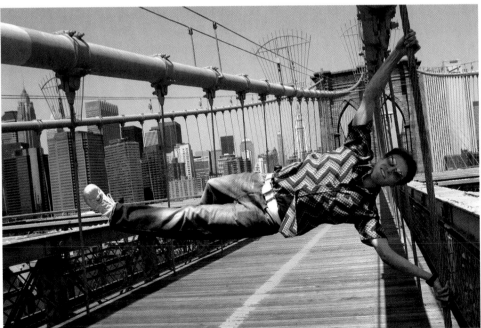

⇑ **Enjoy yourself.** We should take our photography seriously, but if we keep it fun, our final product will reflect the feeling we had when we originally made the picture. There's an old photo adage, one of my favorites: "The camera looks both ways; in picturing the subject we are also picturing ourselves."

⇧ **The name of the game is to fill the frame.** Fill the frame with the subject, and you'll avoid "dead space"—that is, areas of a picture that do not add anything. Use your lens to zoom in— move in closer to fill the frame.

⇧ **See the light.** When looking at a scene, look for highlight and shadow areas that comprise the contrast range of the scene. When shooting digital, you want to expose for the highlights, the bright areas of a scene. In Photoshop Elements, it's relatively easy to bring back shadow detail but difficult to rescue lost highlights.

Set your shutter speed carefully. As you will see in the "Add Motion to Still Subjects" workshop, we can simulate the effect of shooting at a slow shutter speed in Photoshop Elements. In your camera, experiment with shooting with slow shutter speeds (1/30 of a second and below) to add a sense of motion to a picture.

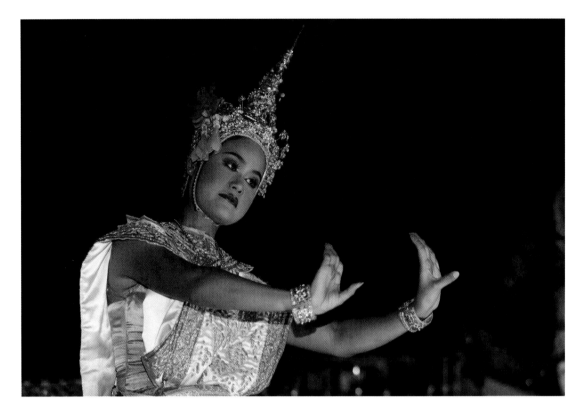

Think flashy pictures. Learn how to use your flash to enhance indoor and outdoor pictures. The photographs of the dancer and the falcon were both made with flash. They don't look like flash pictures because I have learned how to balance the light from the flash with the available light. That's a good thing to know how to do. (Flash photography is discussed in greater detail in my *Complete Guide to Digital Photography*.)

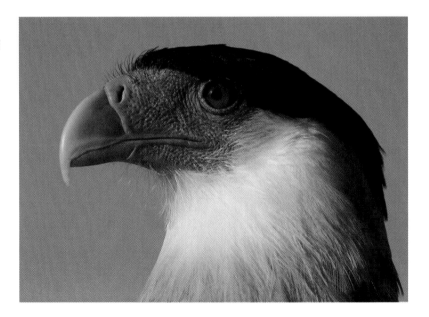

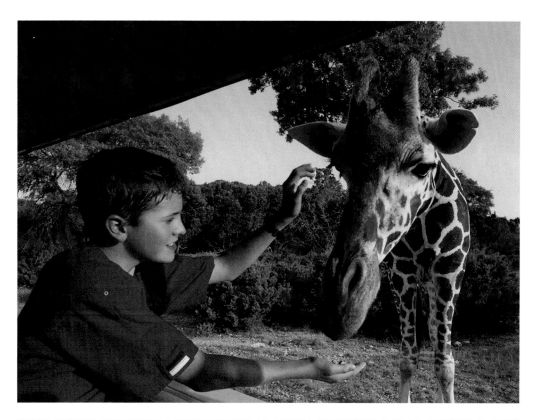

⇑ **You snooze, you lose.** Get up early and stay out late to catch the beautiful light of the "golden hours." Pictures taken at those times have deeper shades of red, yellow, and orange and look more pleasing to our eyes than pictures made around noon, when the light is "cooler," having a blue tint.

Using This Book and CD-ROM

What Makes It Different?

If you are reading this book, you probably realize, as I do, that there are a million books out there on how to enhance pictures in the digital darkroom. There are also many how-to CDs that teach digital darkroom techniques, for the beginner as well as the advanced amateur.

The question is, and it's the same question that I asked myself before I began this project, "What makes this book different?"

To begin with, I'm a professional photographer, first and foremost. Throughout this book you'll gain an understanding of basic photo techniques, illustrated with what I feel are some of my best pictures. With a basic knowledge of photography under your belt, you'll take better pictures in the field and make better images in the digital darkroom.

Second, I've been teaching and writing about digital darkroom techniques for many years. Out of the limitless possibilities that we can achieve in the digital darkroom, I've narrowed this book down to all the basic techniques you need to know. So, this book will give you a good jumping-off point for your own ideas.

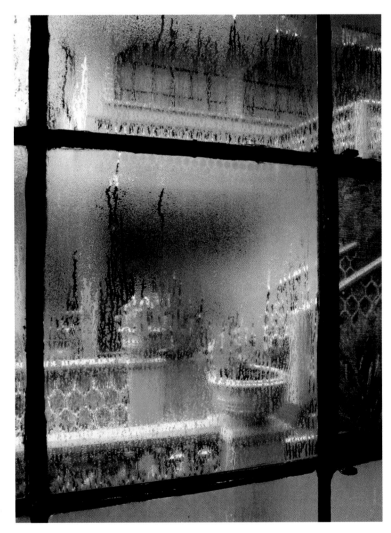

⇒ **Think before you shoot, and set your camera accordingly.** Here I slightly underexposed the image to keep the lighter courtyard from being too bright and focused on the condensed water on the windowpanes with a relatively large aperture to push the background out of focus.

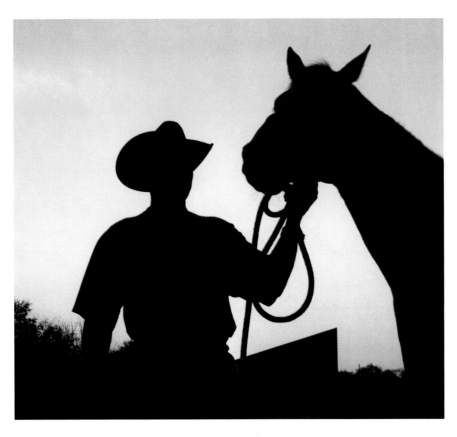

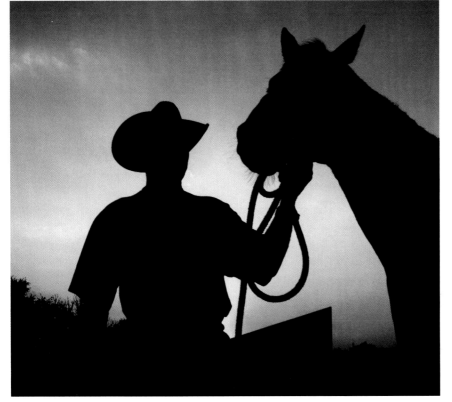

⇐ These before (top) and after (bottom) images of a cowboy and his horse offer a glimpse of what we can do in the digital darkroom in a matter of seconds.

I suggest reading this book in order, starting with "What Can We Do with Digital Imaging?" and "Start in Your Camera" and ending with "Advanced Printing." The book was written that way to guide you through the digital image-editing process, starting with the basics and ending up with having some fun while you are learning.

Two special features of this work will make it easier and more fun for you to learn.

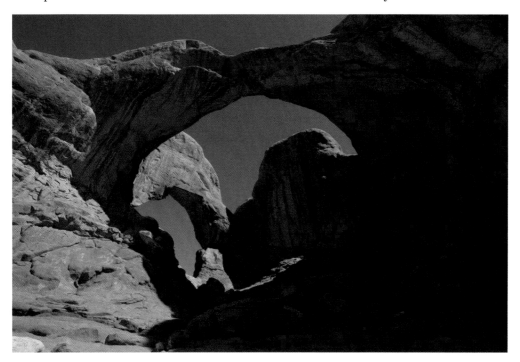

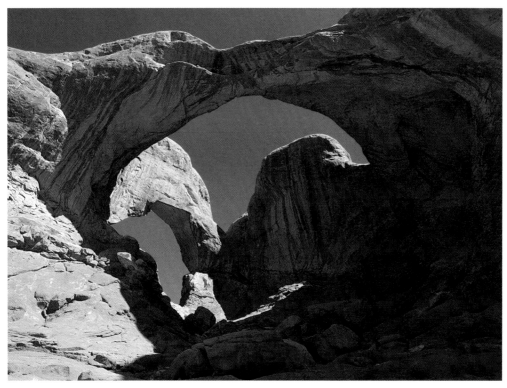

Using Elements, I boosted the color, saturation and contrast of a picture I took at Arches National Park, Utah, transforming a dull shot into a much more dramatic image. You can use the same techniques on your pictures.

Hands-on tutorials. In the Workshop section, you'll find step-by-step instructions on how to transform a photograph, using my image files. These work images are low-resolution files on the CD-ROM that accompanies this book. Play with the images all you want. Have fun! Feel free to use one or two as a screen saver. Please keep in mind, however, that the pictures are protected by international copyright law and can't be used for any commercial purpose without written permission.

Let's go to the movies. The CD-ROM also features mini-tours of the Tool Bar and the Menu Bar for Elements 2.0. These tours, which will help Elements 3.0 users, are viewable as QuickTime movies. If you are not familiar with QuickTime movies, you'll like the two I have included. I use a program called Snapz Pro X to record what I'm doing on my monitor along with my own voice. When you watch the movie, if you miss a part and want to go back, you simply move a slider back to earlier in the movie and watch it again.

In the mini-movies I cover the basics you need to jumpstart your Adobe Photoshop Elements experience. I don't cover every feature, because we'd need several CDs for that task. I do cover the most useful and most common changes we make to our images.

If I could give newcomers to the digital darkroom just one tip, it would be this: Consider how a pianist learns a classical piece. He or she practices a few measures at a time, rather than trying to learn the entire piece in one sitting.

When it comes to working in the digital darkroom, we need to use the same technique: Learn just a few features and techniques in each sitting. Don't try to rush it. What's more, just as a pianist keeps practicing a piece, we need to keep practicing our digital darkroom techniques so we don't forget how to use them.

What Does Adobe Photoshop CS Have Over Elements?

Professional photographers use Adobe Photoshop CS, a full-featured digital imaging program. Most of the practical photographic features of Photoshop CS are found in Photoshop Elements 2.0. We can duplicate some Photoshop CS features in Elements 2.0. with just a few extra steps, as you'll see in this book.

Unique Feature in Adobe Photoshop CS	Purpose
Advanced Color Management	Needed for commercial work, especially by studio photographers.
Added Adjustment Layers, including Curves, Color Balance, Selective Color, and Channel Mixer	Offers more nuanced options while editing an image.
Channels Palette	Offers fine-tuning of individual colors.
CMYK Save As Color Option	Converts an RBG file to a file format required by commercial printers. All the pictures in this book were RGB (red, green, blue) files before they were converted to CMYK (cyan, magenta, yellow, black) files.
Curves	Functions like the Levels feature in Elements but offers more control in diagnosing and adjusting color and light values.
Fade Filter	Lets you fade a filter effect.
History Brush	Paints back an effect.

Although Adobe Photoshop Elements 3.0 lacks the same Photoshop CS features as Elements 2.0, the new program does offer several useful features. See "Warm-up #3: Enter Elements 3.0" for details.

Must-Know Digital Information

The Lowdown on Image Size and Save As

Before we can start working and playing in the digital darkroom, there are two important aspects of digital imaging we need to understand. One is Image Size. The other is Save As, also known as File Format.

⇒ For this lesson we'll use a picture of my son, Marco. It is a copy of the original file. I only work on copies and I never touch my original image files.

⇓ Let's begin with Image Size, which we get to on the Menu Bar by going to Image > Resize > Image Size.

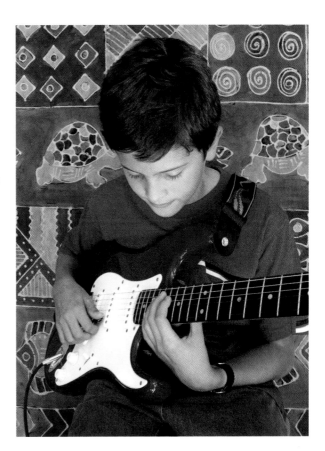

For newcomers to the digital darkroom, understanding picture size can be confusing, because we can't simply look at a picture as a 5 × 7- or 8 × 10-inch print, and so on. There are new factors to consider.

But first, let's take a look at the size of a digital file straight out of the camera.

⇒ Here's a look at the original Image Size dialog box for the image of my son playing guitar. It's typical of the dimensions of a High/JPEG image from high-end consumer digital cameras—that is, the image has both a width and a height of more than 20 inches, and a resolution of 72 PPI (pixels per inch). You'd never make a print that size with that resolution. It would

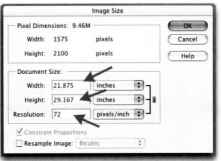

look terrible (very "pixelated"). However, when properly resized for a print or for e-mailing, it will look great! Read on.

⇊ In Photoshop Elements, there are two different ways to view and manage the size of a picture:

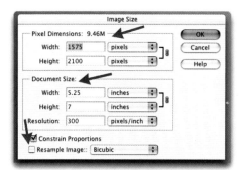

- In pixel (picture element) dimensions (top red arrow). These dimensions show an Adobe Photoshop Elements calculation in pixels of the image's height and width with file size shown as a number of kilobytes (k) or megabytes (M);
- In actual document image size (blue arrow). Inches are shown in this screen shot, but clicking on inches (the default setting) reveals other size choices, including centimeters and millimeters. For most practical purposes, we only need to pay attention to the Document Size and only need to work in inches.

Compare the above screen shot to the screen shot of the Image Size dialog box on the previous page. You'll see that the Pixel Dimensions are the same: 9.46M. However, the Document Size has changed to 5.27 × 7 inches, with a resolution of 300 PPI, which is an ideal size for making an inkjet print. I did that by unchecking the Resample Image box and then by typing in 300 PPI in the Resolution window (see my bottom red arrow). I could also have typed in the new dimensions, which would have changed the Resolution.

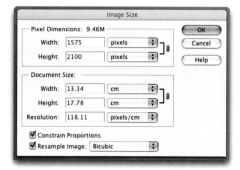

⇑ For Brits and Canadians and others who use the metric system, we can view the document size of the image in other methods of measurements. You do that by clicking on the blue up/down arrows. That's how I got to see the size of my image in centimeters.

File Size Basics

Basically, you want a large file for printing and for publication, and a small file for e-mailing. Large files contain more data, which is necessary for making high-quality desktop prints.

However, large files also take a long time to send over the Internet as e-mail attachments. Small files don't contain a lot of data, which makes them a poor choice for printing, but a good alternative for e-mailing. To avoid starting off with a picture with a low resolution, set your digital camera to either the High/JPEG, or, better yet, the uncompressed TIFF (Tagged Image File Format) or RAW setting, if that choice is available.

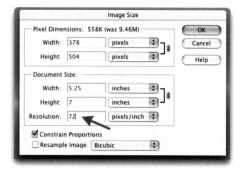

⇑ My 5.27 × 7-inch image with a resolution of 300 PPI is way too large for e-mailing. To reduce the resolution, I typed "72" in the Resolution window. Now the image has the same width and height, but with a lower resolution and less data.

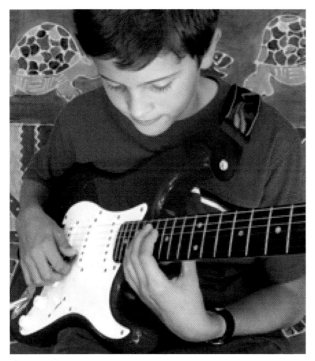
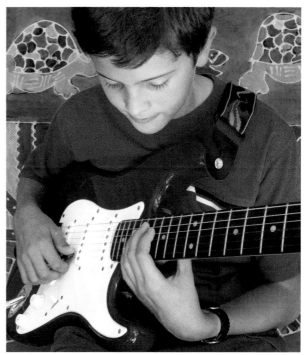

⇑ These two pictures, cropped from my original shot, show the difference between a picture with the same dimensions (5 × 7), but different resolutions (72 PPI on the left vs. 300 PPI on the right). The "pixelated" picture is the image made at 72 PPI. This is how a low-resolution image will print.

There's another reason for downsizing the resolution of an image: filters are applied much faster to small files than they are to large files. So, when experimenting with new filters, play with them on low-resolution images.

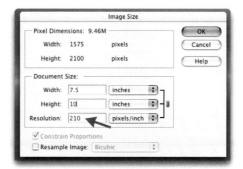

⇒ Let's go over the Resample Image one more time. Again, I admit it can be confusing for the newcomer to Elements. If you want to change all the Document Size settings, uncheck Resample Image. When you do that and type in new numbers, the other numbers change proportionally (make sure all the boxes are locked). This is a fast and easy way to make larger and smaller prints—and to find out the new resolution of a picture.

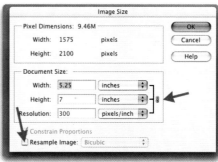

⇒ Enlarging the picture size reduces the resolution—in this case, too much to produce a good desktop print.

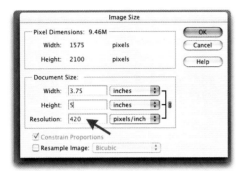

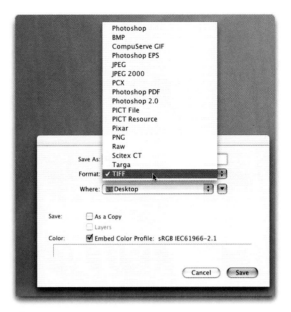

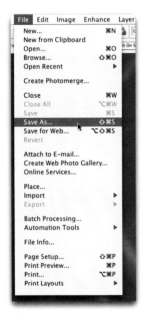

↑ Decreasing the picture size increases the resolution. In this case, we can make a good desktop print.

Save As

Now let's take a look at the Save As command, the way we save our pictures.

After all your hard work in the digital darkroom, you don't want it to go to waste. That can happen if you save a picture in the wrong format.

↑ In the Menu Bar, go to File > Save As.

↑ When you select Save As, the Save As dialog box opens, revealing all the different ways that you can save a photo. JPEG and TIFF are the two most useful formats. Here's the scoop on each.

JPEG

This format was designed to discard information that the eye cannot normally see. The lower the compression ratio (an option when saving a picture as a JPEG file), the greater the loss of image quality and sharpness.

The JPEG format is great for sending files over the Internet and for posting pictures on Web sites, because it compresses an image when it is closed (so it can be sent quickly), and then decompresses it when it is opened (so it opens fast). Because some data is lost—JPEG uses strong compression techniques—all that compressing and sending and decompressing can corrupt, or damage, pixels in a picture, resulting in a loss in image quality.

The real visible damage is done to a JPEG file when it is opened, enhanced and saved, and then reopened to begin the process once again and resaved. Do that several times and you will notice a reduction in image quality. Do that just once, as you may do when you transfer your JPEG files from your camera to your computer, and you will not notice any difference.

Be sure to save your pictures immediately, even before rotating, as TIFF files for the best possible quality.

One advantage to JPEG files is that they don't take up a lot of memory in your computer.

A disadvantage of JPEG files is that, due to the format's compression technique, you can't save a picture in Elements that has Layers that you have created. In the JPEG format, all the layers are merged into one.

TIFF

TIFF is a lossless format. You can open, work on, and save an image countless times without any loss in quality. When you save a TIFF file, you are also saving all the Layers we may have created. So, you can go back to the image again and again and make changes to your heart's content.

TIFF files consume much more memory and hard disk space than JPEG files, so if you're serious about saving your picture files, beef up your computer's memory or get a supply of CDs or DVDs on which to store your pictures.

So, think before you type in new numbers in the File Size image size window and click in the Save As window. Choose your File Size and Save As format carefully. And remember, edit only on copies of your original images so that your original is always left as your "digital negative."

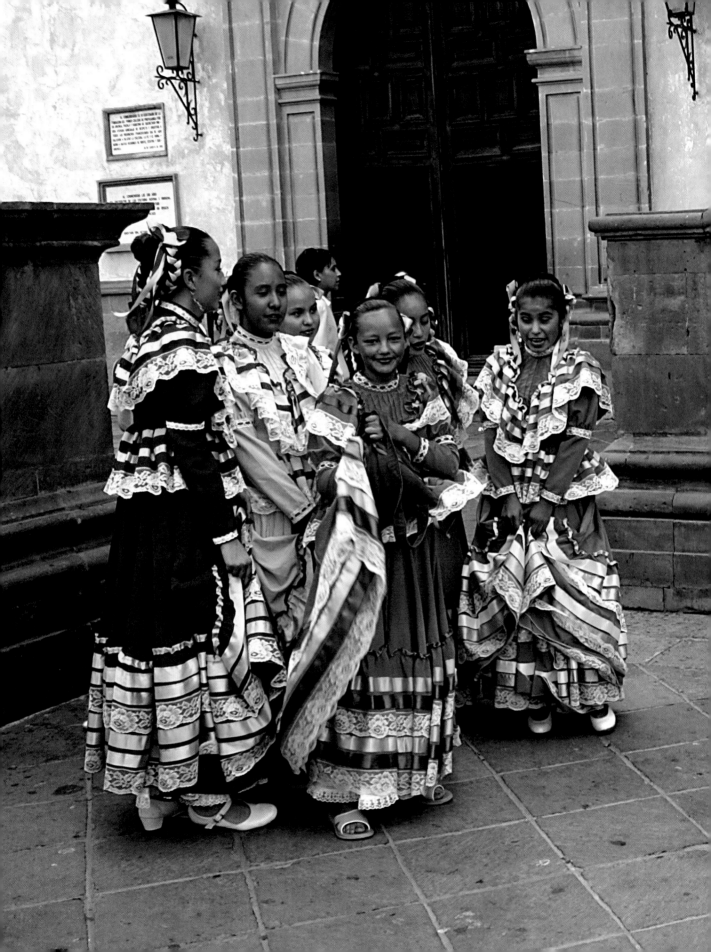

A Tour of the Elements Tool Bar

A must-read for Elements 3.0 users, too.

Before you read this section, check out the QuickTime movie on the CD, where you'll find more information on the Tool Bar.

Also keep in mind that the tools described in this section have the same function as the tools in Elements 3.0. The tools that have been added to Elements 3.0 are described in "Warm-up #3: Enter Elements 3.0."

I would like to change the name of the Tool Bar to the Fun Bar, because that's where the fun begins in Adobe Photoshop Elements. With a few clicks of your mouse, you can enhance, edit, and transform your pictures. So, knowing what the Tool Bar can do is the logical place to start.

In this section, I'll share some examples of using the tools that can expand your creative horizons. But we'll cover all the tools on the Tool Bar.

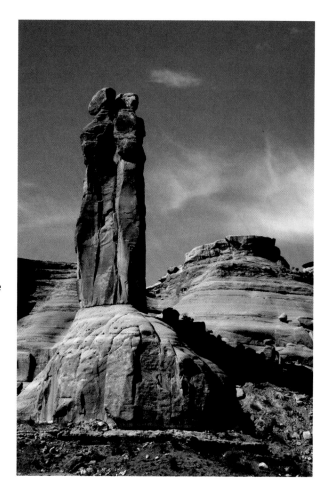

⇒ ⬈ Take a look at the pictures on these two pages. To enhance them I used the following tools:

- Crop Tool to tighten the photograph;
- Eyedropper Tool to pick the color for the type;
- Type Tool to add the words to the picture;
- Burn Tool to darken the corners of the picture.

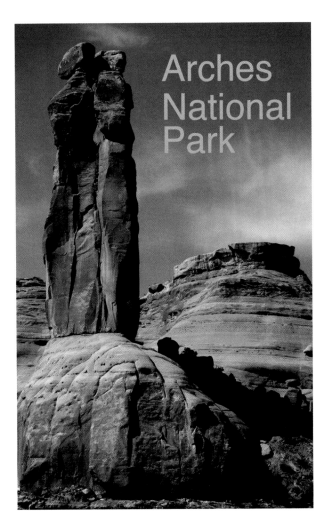

Arches
National
Park

⇛ At the start of each discussion of a tool, I've included the Keyboard Shortcuts, which are the keys on the keyboard that activate each tool. For example, pressing C activates the Crop Tool. You can also see the Keyboard Shortcuts by moving the cursor over the individual tools.

As a reference, here are all the Keyboard Shortcuts:

M = Marquee
B = Move
L = Lasso
W = Wand
A = Selection Brush
C = Crop
L = Line
T = Type
K = Paint Bucket
G = Gradient
B = Brush
P = Pencil
E = Eraser
Y = Red Eye
R = Blur
P = Sharpen
Q = Sponge
F = Smudge
O = Dodge
J = Burn
C = Clone Stamp
I = Eyedropper
D = Default Foreground and Background Colors
H = Hand
Z = Zoom
X = Set Foreground and Background Colors

⇐ You can move the Tool Bar around on your monitor by clicking on the top bar of the Tool Bar and dragging it to another position.

Marquee Tools (M)

⇑ The Marquee Tool is a selection tool. We can use it to select a specific area of a picture, to copy the selection for use in another image, cut the selection to reveal a Layer below the image, or fill with a color. We can select the Rectangular Marquee Tool or the Elliptical Marquee Tool. We simply move the cursor into the image, click, and drag to select a part of the image. Here's a trick: we can move the selection around the image area by holding down the Space Bar.

⇒ Once we select a Marquee Tool, we have several more options, listed under Select in the Menu Bar on the top of the monitor. Here's how those options affect our selection:

All—The entire image area is selected.

Deselect—Undoes a selection.

Reselect—Reselects an area after we chose Deselect.

Inverse—Selects the area outside the selected area.

Feather—Controls the sharpness (actually pixel radius) between the selected and nonselected area.

Grow—Automatically grows selection by expanding the pixel radius.

Similar—Automatically selects areas of a picture that are similar in color.

Load, Save, and Delete Selection—Offers different options for working with a selection.

These screen shots of an owl show the difference between the Rectangular Tool and the Elliptical Marquee Tool and how, by choosing Inverse and by going to Edit > Cut, the image is affected.

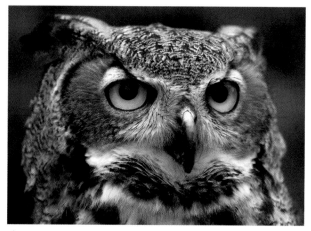

⇑ Original 300 PPI (pixels per inch) picture. PPI is important to know because that affects Feathering (softening or sharpening the area where two effects meet) a selection.

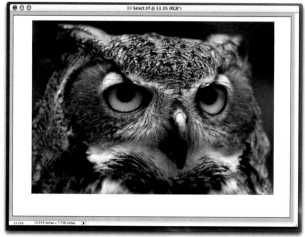

⇑ Rectangular Marquee Tool.

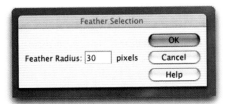

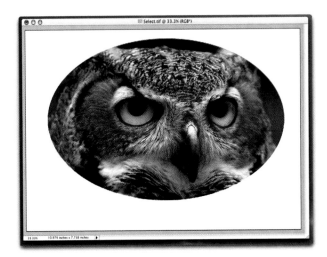

Let's play with the Elliptical Marquee Tool for a bit. If we choose a Feather Radius of 30 pixels, our selection has a hard edge.

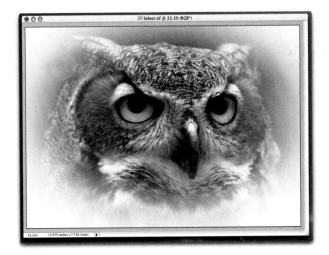

If we choose a Feather Radius of 250 pixels, the edges become much softer. This technique of using a large Feather Radius is good for vignetting (darkening the edges of) a picture.

Move Tool (V)

The Move Tool is used for moving one picture file into another. (We'll cover that in detail in "Workshop #18: Reflections.")

⇊ Let's see how we can use the Move Tool to combine two pictures, taken in San Miguel de Allende, Mexico, a day shot and a night shot, into one image.

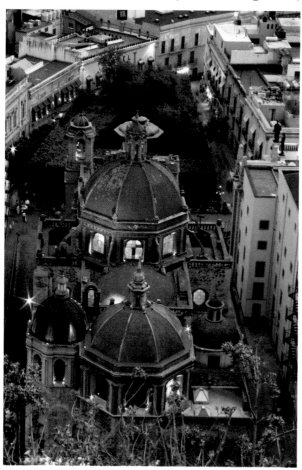
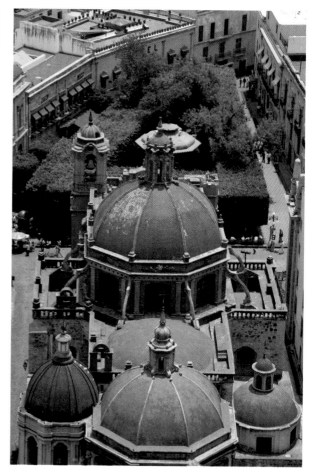

⇒ After opening both images, I horizontally doubled the Canvas Size of the top image (covered in the "Reflections" workshop). Then, after selecting the Move Tool, I clicked on the bottom image, held down on my mouse, and dragged that image into the top image. You can click anywhere in the image you want to move.

Once that image is in the target image, you can use the Move Tool to move the image into any position you desire.

⇓ Here is my final two-in-one image.

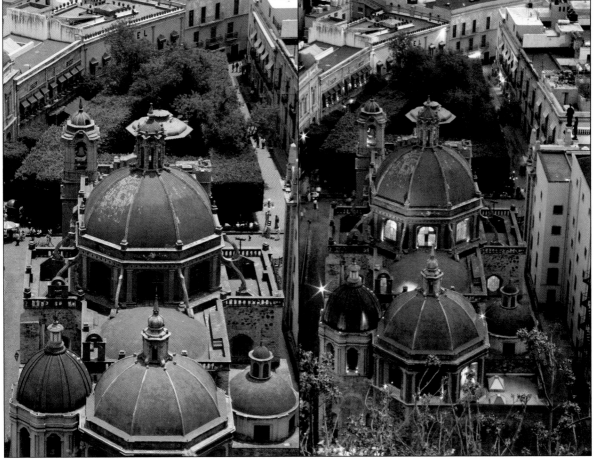

Lasso Tool (L)

When we click on the Lasso Tool, we have three options: Lasso Tool (freehand lassoing), Polygonal Lasso Tool (for selecting squares and rectangles), and Magnetic Lasso Tool (for easily selecting an area of picture with the same color value).

⇓ Compare these two images. I used the Lasso Tool to trace the angel's pink dress and then, using Hue/Saturation, changed the dress color to blue. Then I used the Polygonal Lasso Tool to select the sign, inverted my selection (Select > Inverse), and boosted the saturation (Enhance > Adjust Color > Hue Saturation) of the now-selected image area. The sign area was left unadjusted.

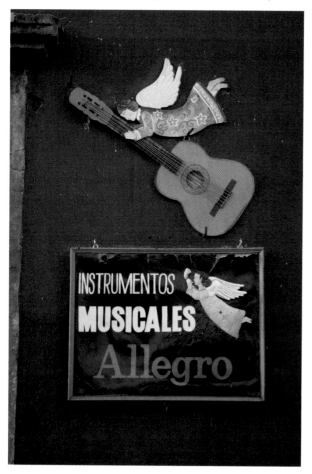
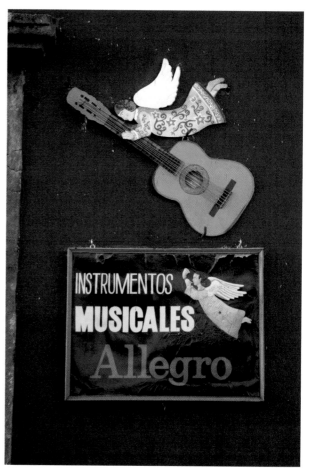

Magic Wand Tool (W)

The Magic Wand Tool lets us select areas by color value. We simply click in an area and all the area with the same color value will be selected.

⇓ For this before-and-after set, I selected the dull sky and then enhanced the color by going to Enhance > Brightness/Contrast > Levels.

Selection Brush Tool (A)

The Selection Brush Tool lets us "paint" a selection. We simply move the brush over an area and that area is selected. What could be easier?

⇓ In this example, I used the Selection Brush Tool to paint/select the girl's eyes. Then I boosted the Contrast and Brightness by going to Enhance > Adjust Brightness/Contrast.

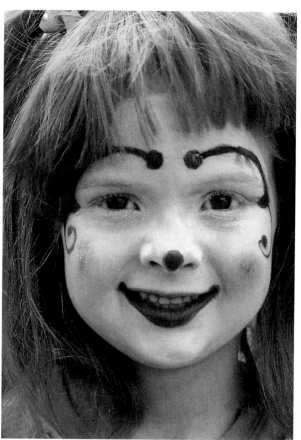
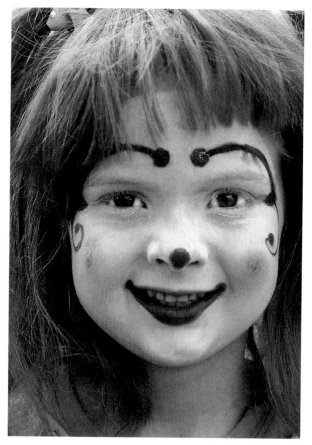

Corrective and Creative Uses for the Crop Tool (C)

We'll spend a bit more time on the Crop Tool than on some of the other tools, because it can be used for more than simply cropping. However, we'll start with simple cropping

To use the Crop Tool, select it from the Tool Bar, and click a point inside your image that could make a good cropping point (top left or top right). Then, drag your mouse to a point diagonally opposite the first crop point and release your mouse. The cropped-out (removed) area of the image will be darkened. Press Return to crop your image.

The Crop Tool is most often used for trimming a picture—cropping out unwanted "dead space" in an image to give the picture more impact. Here is an example of how effective cropping can be. I enlarged the picture on the right after it was cropped.

The Crop command will crop every layer in your image to the same height and width. I make a habit of saving each crop of an image with a new file name. This extra step lets me go back to the original larger image later without having permanently lost the cropped areas.

We can also use the Crop Tool to adjust the horizontal axis of a picture—in this example, straightening a tilted horizon line.

⇒ As you can see, this picture looks as though it is running downhill to the left of the frame.

The fix is fast and easy.

⇓ First, we go to the Menu Bar on the top of the monitor and then select View > Zoom Out.

⇑ Now, click on the bottom right of the picture frame and pull it down and to the right.

⇑ The "shrunken" file looks like this: The picture is now surrounded by a neutral gray area.

The next step is to crop inside the picture area and release the mouse.

⇒ Next, we move the cursor outside of the picture area into the gray area. At that point, moving the cursor changes it to a curved, double-headed arrow that gives us the option of cropping and rotating the picture. All we have to do now is visually line up the horizon line with the bottom dotted line created by the Crop Tool. Click and our picture will be straightened.

Finally, we can use the Crop Tool again to crop out the blank areas created when we cropped the picture at an angle.

⇑ Here's my corrected picture. Now the horizon line is level.

⇓ My picture now shows a fairly tight crop, the way I personally like to display my images. What's more, I also enhanced the color and brightness of the final picture.

⇊ In addition to straightening the horizon line with the Crop Tool, we can tilt it for a more dramatic effect. Simply use the same technique as described previously. Here's an example of how tilting the horizon line can add more impact to a picture of a young dancing couple.

Line Tool (U)

The Line Tool can be used to draw straight lines going in any direction and with arrows at either end. It also comes with many shapes you may incorporate into your images.

⇐ Clicking on the Custom Shape arrow (my top red arrow) gives us access to many custom shapes. To see all the shapes, click on the Custom Shape fly-out arrow (my green arrow) and then click on All Elements Shapes (my red arrow on the right).

⇒ Let's make a postcard of this red Volkswagen I photographed in San Miguel de Allende, Mexico.

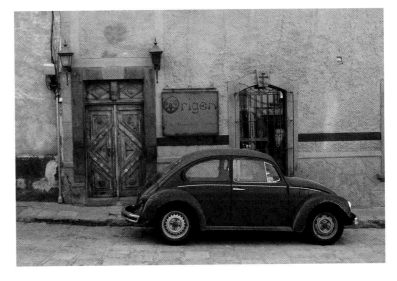

⇒ Among the Custom Shape groups I selected this shape, Frame 15, that seems to fit the scene. I click on the background image to locate the frame. Elements places the frame on a new layer called Shape 1.

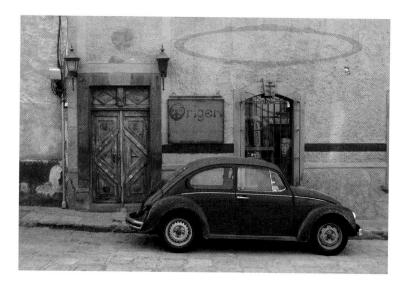

⇑ I then faded the Opacity of the Shape layer so the frame would not distract us from the objects in the image or the type to come. Now we are ready for the Type Tool.

Type Tool (T)

The Type Tool is used for adding type to an image. We can add either Horizontal or Vertical type to your image. We'll look at this feature in more detail in the "Type" workshop.

⇒ Select the type font and the size and color you want, move your cursor into an image, and begin typing. It's that simple. Adding the type to this image took all of ten seconds.

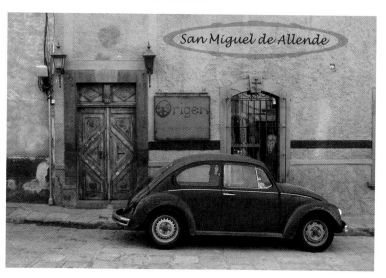

Paint Bucket Tool (K)

The Paint Bucket Tool lets us fill in areas of a picture with a click of the mouse. But we need other Elements features to become a "painter." Actually, it takes several steps to spill the paint bucket into an area. Here's how to do it.

⇓ First, select an area of picture that you want to paint. In this example, I want to paint the black area maroon.

⇓ Next, I selected a paint color using the Set Foreground Color Tool at the bottom of the Tool Bar (read about it at the end of this section).

⇓ Next, I went to the Menu Bar at the top of the monitor and then went to Edit > Fill.

⇓ The default window that opens shows the Foreground color selected. Click OK.

⇓ Presto, I painted over the black area with a new color!

Gradient Tool (G)

The Gradient Tool is used for creating subtle changes in color in a smooth pattern in a document. We can enhance a dull sky with this tool. We can also have some fun with it. Let's start with the fun!

⇓ To see many of the Gradient Tool options, first select the Gradient Tool and click on the Gradient window at the top of the Menu Bar (see my blue arrow), and then click the fly-out arrow (see my red arrow). Click on the different options to find one you may want to work with.

⇓ In the accompanying example, an opening slide for a digital slide show, I picked a yellow/green/blue Linear Gradient.

Summer of Fun

2004

⇑ To apply a Gradient, we move our mouse into a document, click, drag the cursor up, down, left, right, or diagonally in an image, and release. Here I clicked at the bottom of the image, dragged my cursor to the top of the image, and released my mouse.

Now let's see how we can enhance a dull sky.

⇓ We'll use a photograph of Horseshoe Bend in Page, Arizona, in this example. Notice the washed-out sky.

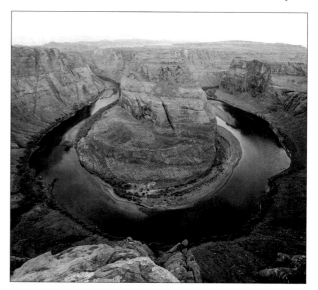

⇩ First, I used the Rectangular Marquee Tool to select the sky area on the top layer.

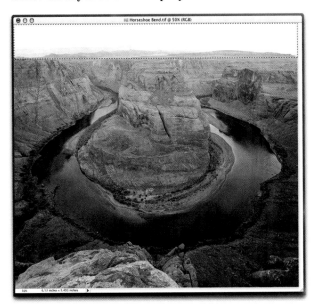

⇩ Next, I selected a light blue (you can choose light, dark, or medium blue to your liking) from the Set Foreground Color Tool at the bottom of the Tool Bar (see the end of this section for tips on using this tool). Then, I went to the Menu Bar at the top of my monitor and selected a Linear Gradient effect.

⇩ Finally, I moved my cursor into the picture and clicked at the top of the selected area and dragged the tool straight down. When we drag the tool, we create the effect of going from a dark to a light gradient.

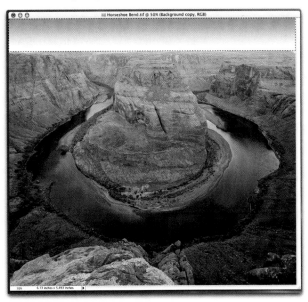

⇩ The last step is to deselect the selected area. Do that by going to the Menu Bar, then Select > Deselect to remove the "marching ants" (dotted white lines).

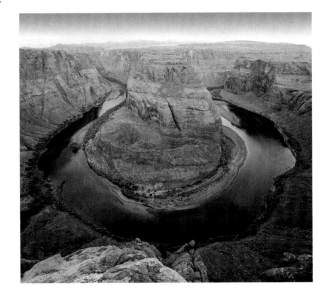

Brush Tool (B)

Within the Brush Tool there are two brushes, the Brush Tool and the Impressionist Brush Tool.

First, I will discuss the Brush Tool. The Impressionist Brush Tool is next.

⇑ The Brush Tool can be used for selecting a style and size of brush. After clicking on the Brush Tool icon, we can go to the Menu Bar at the top of our monitor and click on the small arrow next to the brush style to see some of the brush options. For even more brush options, we click on the fly-out arrow, which reveals a window with the options.

Once a brush is selected, we selected another Tool, say Burn or Dodge (covered soon) and then "paint" over an area in a picture.

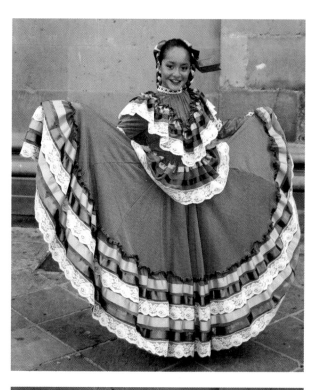

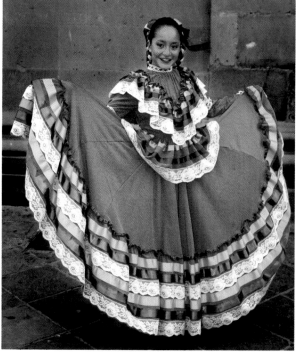

⇑ In this before-and-after example, I selected an airbrush, then the Burn Tool, and "painted" the edges of the picture to make the subject stand out more in the scene.

⇒ With the Impressionist Brush, we can transform our pictures into works of art that look as though a master Impressionist painter created them. (Okay, maybe just an Impressionist painter!)

The effect is quick, easy, and fun. There are, however, two tricks you need to know.

⇒ In this lesson, I'll use a photograph of a sailboat that I took in Maine while teaching a workshop for the Maine Photographic Workshops in Rockport.

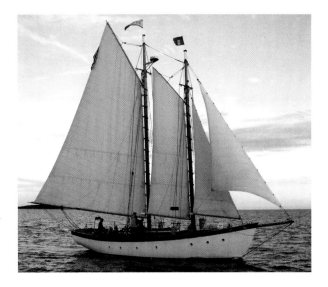

⇓ We have several choices for the style of brush we can use to "paint" over your image. To reveal the brushes, we click on the Brush menu in the Tool Bar. You'll then see a list of brushes and their effects in a new window. We have access to even more brushes by clicking on the arrow fly-out button. When we do that, we get a window from which we can load new brushes.

There are two keys to getting a pleasing effect. One, select a brush style that perhaps a painter would use; don't select an oval or square brush. Two, select a small brush size. We can change the size of our brush simply by using the bracket keys—[]—on the

keyboard: the left bracket makes the brush smaller, the right bracket makes the brush larger. You can use this keyboard shortcut to change the size of your brush in all the other tools that use a brush.

⇓ After we have selected our bush style and size, we simply paint over our entire picture area. Tip: Take your time, because creating a work of art usually takes some time.

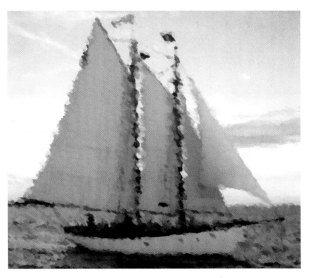

Pencil Tool (N)

The Pencil Tool functions as a digital pencil, allowing us to write in an image with a pencil stroke.

⇒ After we select the Pencil Tool, we can see other options by going to the Menu Bar at the top of our monitor, clicking on the down arrow to see the brushes, and clicking on the fly-out arrow.

⇓ Here's an example of how you can use the Pencil Tool to digitally autograph a photograph.

Eraser Tool (E)

Within the Eraser Tool icon on the Tool Bar there are three erasers: the Eraser Tool, the Background Eraser Tool, and the Magic Eraser Tool. The Eraser Tool is often used with Layers, which is described in the "New Layers" workshop. You may want to check this lesson after you read this section.

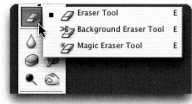

Here's a brief introduction to Layers. You have two pictures on your desktop, one placed perfectly on top of the other—creating two layers of pictures. In Photoshop Elements, these Layers are created digitally. It's the same concept as with the pictures on your desktop. Somewhere on your hard drive, you have two pictures, one on top of the other.

With that in mind, the Eraser Tool erases a selected part of the top image to reveal the image below. Here are examples of how the Eraser Tool works.

⇊ We'll use a two-layer document, created by combining a picture of a butterfly shot on the top layer and a seaside scene shot on the bottom layer.

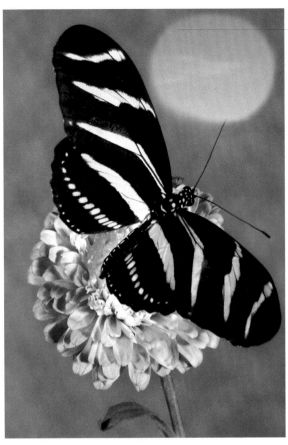

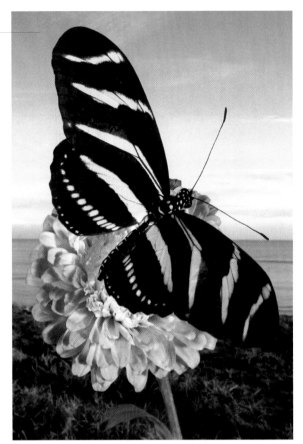

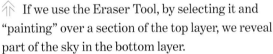 If we use the Eraser Tool, by selecting it and "painting" over a section of the top layer, we reveal part of the sky in the bottom layer.

If we use the Magic Eraser, by selecting it and simply clicking on the blue area, all the blue background on the top layer is erased (because the Magic Eraser selects an area by color value).

If you were only working with one layer and used the Magic Eraser on my butterfly shot, the background would look like this, because there is no bottom layer.

If we use the Background Eraser, by selecting it and then by tracing the main subject, the background is erased, because, as with the Magic Eraser, this tool makes its selection by color value.

When used correctly, the Background Eraser and the Magic Eraser can produce similar results.

Red Eye Brush Tool (Y)

The Red Eye Brush Tool has one major function: removing the dreaded red eye from a picture of a person. After selecting the Red Eye Brush Tool, select a brush size about the same size as the subject's pupil and click your mouse until the red is gone. This tool desaturates the red color in the selected area.

⇐ Here is an example of how effective this tool is in removing red eye. We'll meet the rest of this boy later on in this book.

Blur (R) and Sharpen (P) Tools

I've combined the Blur and the Sharpen Tools into one section because we use the same techniques to apply the effects to a picture.

 After selecting either Blur or Sharpen, we set the brush size and then "paint" in the blur or sharpen effect in an area of a picture. Note that the longer we "paint" over an area, the more intense the blur or sharpen effect becomes.

⇒ In this before-and-after example, I used the Sharpen Tool to sharpen Marco's face and I used the Blur Tool to blur the background.

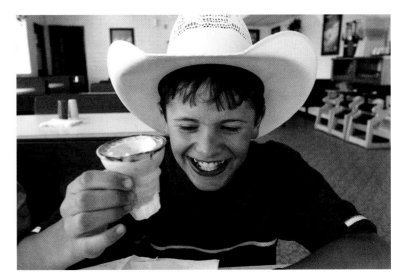

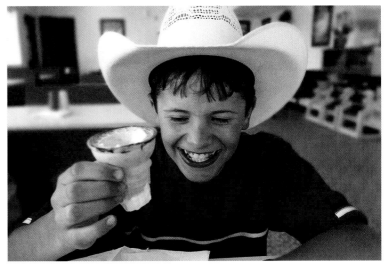

Sponge Tool (Q)

The Sponge Tool lets us selectively
saturate or desaturate areas of an image
you paint over with a brush.

\Rightarrow After we select the Sponge Tool, we
go to the Menu Bar at the top of our
monitor and select either Saturate or
Desaturate. Then we set your brush size
and start painting over the area you
want to change.

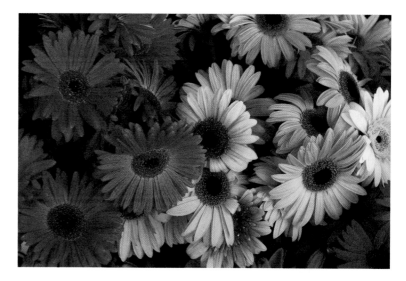

\Rightarrow In the before-and-after example,
I desaturated one of the flowers and
saturated the center area of all the
other flowers.

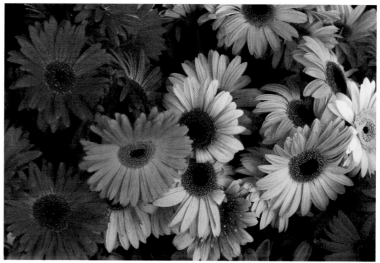

Smudge Tool (F)

The Smudge Tool lets us smudge (blur and pull) areas of a picture for creative and interesting effects.

After selecting the Smudge Tool and setting a brush size, we move your brush over the areas of a picture we want to smudge.

⇓ In this example, I smudge the edges of this flower by clicking on the edges of the flower and then by pulling my brush outward.

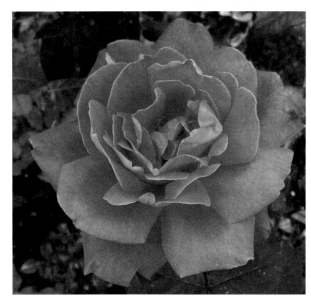

Dodge (O) and Burn (J) Tools

I've chosen to include both the Dodge and Burn Tools in one section because we use them the same way, but for opposite effects.

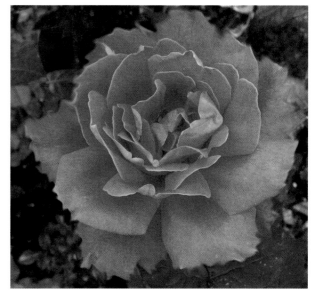

Since the early days of photography, film photographers have been burning (darkening parts of a picture to correct for an overexposed area of a scene), and dodging (lightening) to correct for an underexposed area. In this section, we'll talk about both burning and dodging.

⇒ Here's the key to using these tools effectively. Go to the Menu Bar at the top of your monitor and click the Exposure slider. If the slider is set at 100 percent, you'll alter an area of your photograph quite rapidly with less control over the effect. A better choice is to set the exposure at around 50 percent before using the tool. In fact, you may want to start at an even lower percentage for a more subtle effect.

After you have set the Opacity, set your brush size.

⇑ Here is a before-and-after example of how the Dodge Tool was used to lighten the little boy's face.

⇓ Impressionist painters used to darken the edges of their pictures to draw more attention to the main subject. You can do that, too, no matter what your subject. Here I darkened the carved stone background to draw more attention to my model's face.

When looking at your pictures, keep in mind that selective burning and dodging may enhance an image.

In Photoshop Elements, there is another way that you can dodge a subject's face. Let's take a look.

⇒ In this example, we are going to use the Photoshop Elements Fill Flash (Enhance > Adjust Lighting > Fill Flash) command to brighten my son, Marco's, face.

⇒ Before we apply that effect, let's take a look at what happens when we use the Dodge Tool to lighten the face of a very dark subject. As you can see, Marco's face is lighter, but the tone is flat.

⇓ When you choose Fill Flash, the Adjust Fill Flash dialog box opens. At this point, you can control the brightness and saturation of the effect.

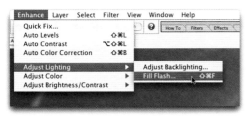

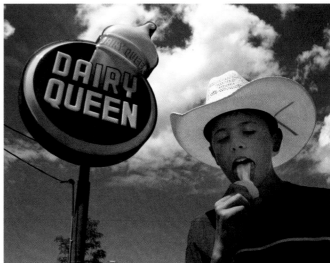

⇒ Here's how my photo looks with Fill Flash applied. Now we can see Marco's face, but the overall image is lighter, too.

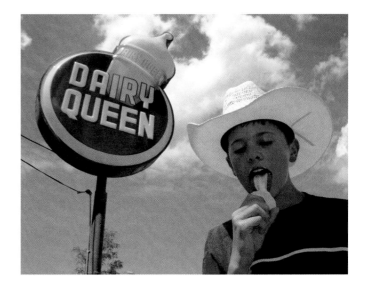

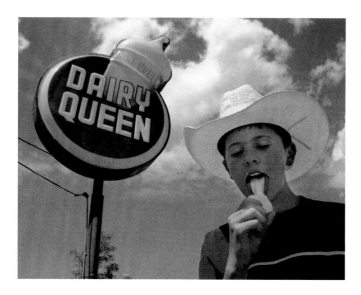

⇐ No problem. Now we use our Burn Tool to darken areas of the scene except for Marco's face.

Clone Stamp Tool (S)

The Clone Stamp Tool is important. It allows us to replace an unwanted area of a picture with an area from elsewhere in the photograph. Using it is a several-step process:

One: Click on the Clone Stamp Tool in the Tool Bar.

⇒ Two: Select a soft-edged brush.

Three: Place the brush (change the size with the bracket keys on the keyboard—right for larger, left for smaller, or set with a slider on the Menu Bar) over an area of a picture that you want to pick up and paste over another part of the picture. Press and hold down the Option (Mac) or Alt (Windows) key.

Four: Click your mouse and release. That area is now "picked up" and is placed in your computer's memory.

⇒ Five: Move your brush over the area that needs to be removed and start "painting over" that area. As you move your brush, the area around your initial pick-up point will also be moved. The area that you are picking up is indicated by a plus sign, and the area on which you are painting (cloning) is shown by your brush.

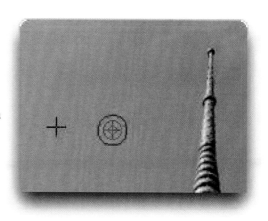

Here are two examples of how the Clone Stamp Tool saved the day for me.

⇒ While photographing in Bangkok, some dust specks got on my digital SLR's image sensor.

⇓ These tiny specks show up as much larger marks in a photograph. To see them on your monitor, use the Zoom Tool and enlarge suspect areas of a picture.

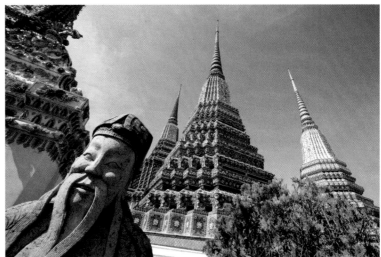

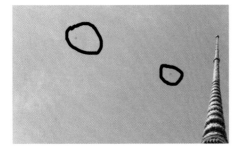

⇒ You may not be able to notice that I've removed all the marks in this frame, but in a large print, you certainly can.

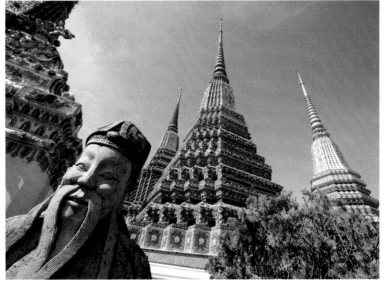

⇐ Here's another tip for reducing dust spots in an image. Most dust collects around the edges of the image sensor. Even cleaning the sensor does not always remove all those specks. Knowing that, leave just a bit of room around the main subject in a scene. In other words, leave room for some digital darkroom cropping. Using the Crop Tool, you simply crop out the "dirty" area of your picture.

⇒ Here's another example of how to use the Clone Stamp Tool.

I photographed my wife, Susan, hand-feeding a giraffe in Fossil Rim Wildlife Center in Glen Rose, Texas.

If you look between Susan's teeth, it looks as though there is a leaf floating in her mouth. It's actually a reflection of a stripe on a bag that's on the dashboard.

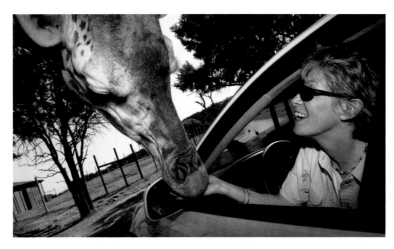

⇒ Using the Clone Stamp Tool, I picked up the surrounding black area of the bag and pasted it over the leaf.

Once again, the Clone Stamp Tool saved the day.

⇓ Compare these two pictures. In the right-hand picture, I used the Clone Stamp Tool to remove eight areas of the scene. Can you see all eight? (Photo by Marco Sammon of his dad getting ready for paintball.)

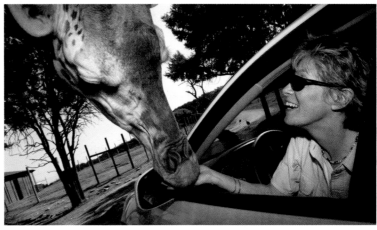

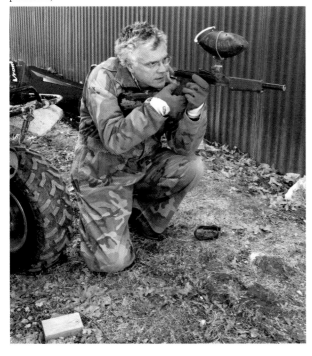

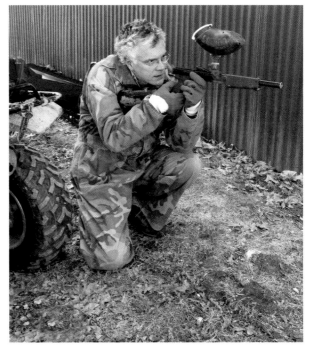

Eyedropper (I) and Set Foreground and Background Colors (X) Tools

Once again we'll take a look at two tools that work together: the Eyedropper Tool and the Set Foreground and Background Tool. Both these tools are used for picking and choosing colors, which is why I grouped them together here.

Let's look at Set Foreground and Background first.

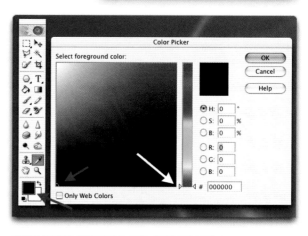

⇒ When we click on either the Set Foreground color box (large left box, bottom left red arrow) or the Set Background Color box just behind and below it, the Color Picker dialog box opens, and the color that is picked is indicated by a circle in the window (small red arrow). This screen shot shows the default setting, black as the foreground color, white as the background color. To view new colors, move the little triangles on the color bar up (white arrow).

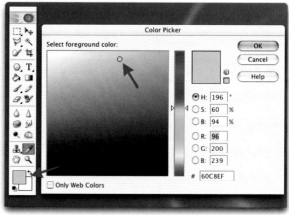

⇒ We pick a color by moving the cursor around the window, and by scrolling up and down the color slider. When we click over the new color, that color is set as the foreground color. Notice that the color in the small circle matches the color in the Color Picker.

⇓ With a new foreground color, we can get to work and start to have color fun with an image. Here I set the foreground color to a light blue and gave a full color picture a light blue tone by adding a Color Layer (see the "Add Color to Black and White" workshop for information on adding a Color Layer).

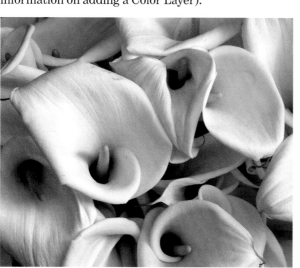

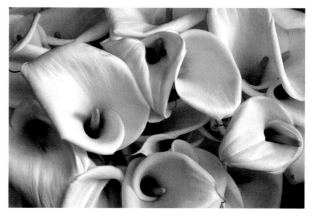

The two smaller icons in the Color Picker section of the Tool Bar can be useful. The left icon (small boxes) resets the Color Picker to its default setting. The right icon (double-ended arrow) switches the colors back and forth.

Now let's take a look at the Eyedropper Tool.

⇒ The Eyedropper Tool can be used to pick up a color from an image. Let's see how that works with a macro picture I took of a beautiful orchid.

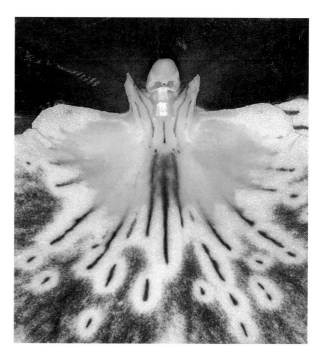

⇑ After we select the Eyedropper Tool, we move the Eyedropper into the image area. When we click on an area of the image, the color in that area becomes the foreground color.

⇒ After a new foreground color is set, one of the things we can do is type with the exact same color within an image, which is fun when making our own posters, promotional flyers, and postcards.

Orchids of the World

Hand (H) and Zoom (Z) Tools

We'll end our roundup of the Elements Tools by once again combining two tools, the Hand and Zoom Tools.

⇒ Here's a shot of a Faithful Beauty moth I photographed near my home.

⇓ Here's a screen shot of the same image.

⇒ To reduce the size of an image on your monitor, select the Hand Tool and move the cursor into the image. When you press Option (Mac) or Alt (PC), the hand icon becomes a little magnifying glass with a minus (-) symbol in the glass area. While holding down the key, click your mouse to reduce the size of the image. Why would you want to do this? It's another way to reduce the image size so you can use the Crop Tool for straightening the horizon line and for using the Transform function (covered later in this book) to straighten buildings.

You can also use the Hand Tool to magnify the image. For this effect, hold down the Command (Mac) or Control (PC) key.

⇒ The Zoom Tool lets you zoom in and out of a picture. When you move the tool into a picture, your cursor becomes a little magnifying glass with a plus (+) in the glass area. When you click your mouse, your picture is enlarged because you are zooming in on the picture. This is great for checking out the detail in the picture. When you hold down the Option (Mac) or Alt (PC) key, you get a little magnifying glass with a minus (-) symbol in the glass area. Clicking your mouse now zooms out and your picture becomes smaller, just as it did when the Hand Tool was used.

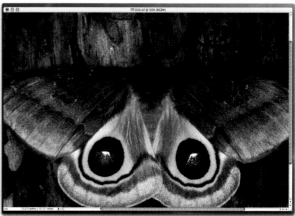

WARM-UP #2

A Tour of the Menu Bar and Tab Dock

LEARN ABOUT

Preferences	Quick Fix	Remove Color	Layers
Batch Processing	Hue/Saturation	Replace Color	Filters
Canvas Size	Focus	Color Variations	Effects
Histogram	Rotate	Levels	Undo History

Before you read this lesson, please view the short QuickTime movie on the CD called Tour of the Menu Bar.

On these book pages, we will visit places on the Menu Bar and its Tab Dock for a bit more detail than we see in the movie. As with the prior tour of the Tool Bar, this section is organized geographically to visit the most helpful items in the Menu from left to right and within individual Menu items from top to bottom.

⇓ You will notice several differences between the Tool Bar and the Menu Bar and Menu Tab Dock. The Tool Bar is vertical and can be moved to different locations on your monitor. Most of its tools let us make changes, adjustments, and enhancements to individual areas within an image.

⇒ The Menu Bar is located at the top of your monitor when you open Elements. The items on the left side of the Menu are locked in position and always stay in place. However, by clicking on the Menu's folderlike tabs on the right side of the Menu, called the Menu Tab Dock, you can drag them down into another, perhaps more convenient, location on your monitor.

⇒ Here I have dragged down the Filter Palette onto my work area. Likewise, we can drag palettes back to the Menu Tab Dock, when we are finished working on an image.

Menu functions usually make what we call "global" changes to an image—that is, they affect the entire image. The features we find on the Menu can greatly expand our creative horizons. In this lesson, we will look at a few of the features that I feel are most useful for photographers.

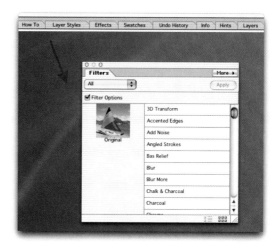

Preferences (Photoshop Elements > Preferences)

We need to set our personal Preferences for Photoshop Elements. One of the most important settings is Display & Cursors. I recommend leaving the settings for the Painting Cursor at Brush Size and Other Cursors at Standard. Those settings make it easy to see what you are doing on an image. If you have followed my advice and don't get those settings, you accidentally pressed the Caps Lock button on your keyboard. If you want to specify metric units, go to Units and Rulers and change Rulers to cc or mm.

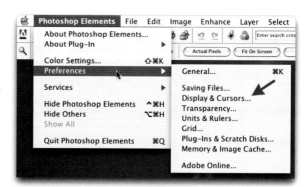

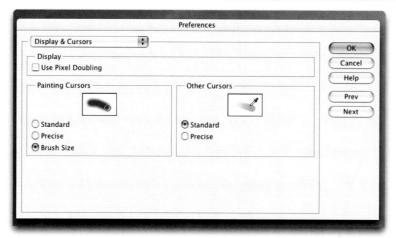

Batch Processing (File > Batch Processing)

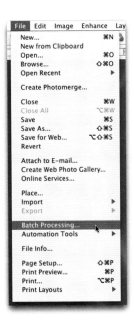

Batch Processing is a fast and easy way to change the size and type of several files and move the new files into a different folder. This is a five-step process.

1: Selecting File > Batch Processing opens a dialog box that lets you choose a Source Folder. This folder contains the image files that are the "Files to Convert."
2: Select a Conversion Type. For example, you may have TIFF files and want to convert them to JPEG for e-mailing or posting on a Web site.
3: Set the Resolution.
4: Rename your files (if you want).
5: Set a Destination folder. When you click Destination from the pop-up menu, another dialog box opens that lets you either chose an existing folder or set up a new folder.

When working in the digital darkroom, Batch Processing can save you lots of time. I used Batch Processing to create JPEG files of these eight images for a "Fun Stuff" folder after I had edited them.

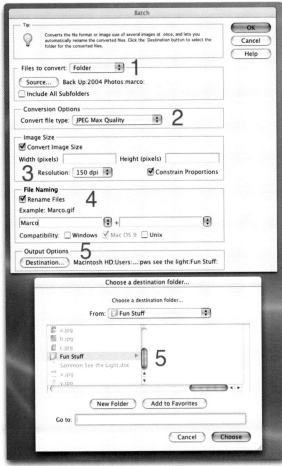

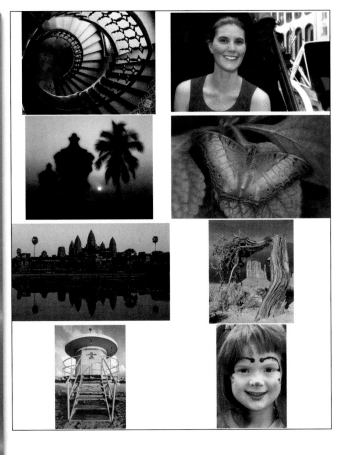

Increasing Canvas Size
(Image > Resize > Canvas Size)

Increasing the Canvas Size is different from increasing Image Size (covered in the earlier lesson on "must-know digital information"). Canvas Size is useful when you want to create a new blank area to include two pictures in one file. Here I want to place two portraits taken in India side by side. Let's start with the young woman in a train station in Rajasthan, India.

When selecting Image > Resize > Canvas Size, the Canvas Size dialog box opens. The Anchor Point in the center of the frame is automatically selected. To change the Canvas Size, click in one of the other boxes. The area opposite your selection will be increased. Here I selected the right box because I wanted to expand the Canvas Size to the left of my original picture of the girl. After you increase the Canvas Size, you can drag another picture into the newly created area, in this case, a train station porter from the same city in India.

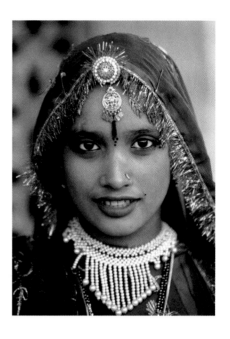

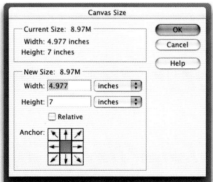

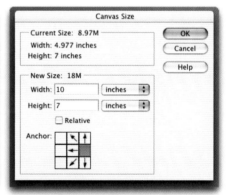

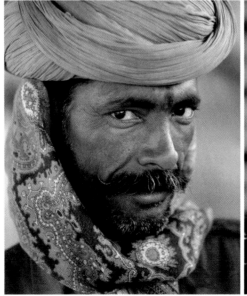

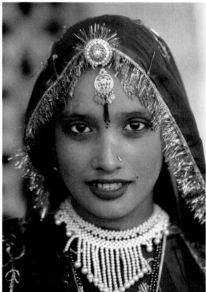

Histogram (Image > Histogram)

Histogram (as you'll read in the first workshop, "Diagnose the Image") has nothing to do with Undo History, which lets you get back in the "history" of making changes to an image. Rather, a histogram is simply a precise indication of the brightness values in a picture, the dark areas on the left and the bright areas on the right. We cannot adjust those values in Histogram. We need to go to the Levels feature to do that.

⇓ This histogram shows the brightness range for this picture of a snorkeling young woman from the Maldives. Some shadows and highlights are missing, indicated by the fact that the "mountain range" does not fully extend to the end of the Histogram window. See the Levels section to see how we can fix that.

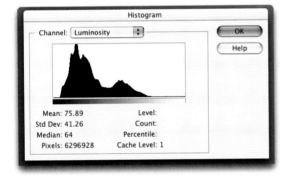

To learn more about Histogram (and there is a lot more to know), click on Help in the Histogram dialog box. We will see histograms again shortly, when we tour the Levels command.

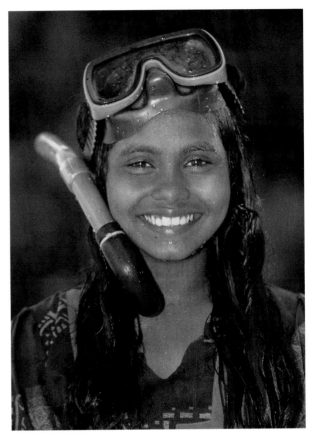

Quick Fix (Enhance > Quick Fix)

Quick Fix is a good starting point when working on a picture. It offers many preselected adjustments for exposure, color, contrast, and even focus.

Brightness/Contrast (Enhance > Quick Fix > Brightness/Contrast)

In this example, I just slid around the Brightness/Contrast settings to see what improved my image most.

I started with the portrait on the left. The portrait on the right shows how Quick Fix affected my picture when I lowered the Brightness only and then clicked Apply. A pretty good quick fix, indeed!

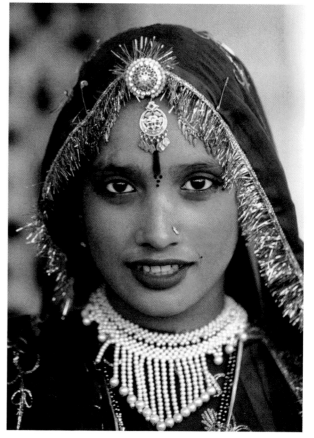

Color Correction (Enhance > Quick Fix > Color Correction)

⇒ Click on Color Correction and Auto Color and then click Apply.

⇓ Using Elements, here is a Quick Fix in Auto Color. It's a "cooler" version of my original picture, which was taken in the late afternoon in "warm" light. Not a terrific result!

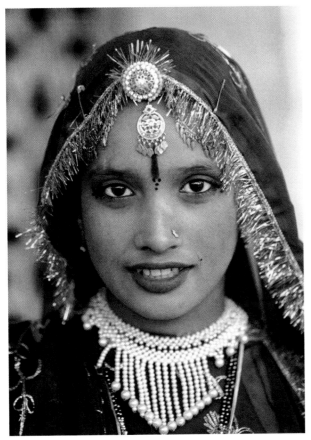

I don't rely on Quick Fix, because it applies a change evenly to the entire image. Usually I want more creative control. But Quick Fix is helpful if you want an instant preview of whether to adjust brightness or color. Sometimes you, like me, will not agree with Elements. Quick Fix offers other options with which you may want to experiment.

Hue/Saturation (Enhance > Quick Fix > Color Correction > Hue/Saturation)

⇒ Click on Color Correction and then Hue/Saturation. Move sliders for the hue (range across the color spectrum) or saturation (specific color intensity) to create your own custom color correction. I boosted the Saturation just a bit.

⇓ Do you notice a slightly richer skin tone than on the previous page?

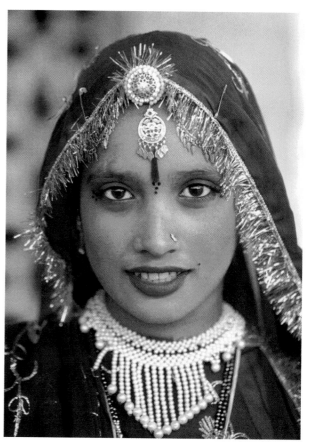

Focus (Enhance > Quick Fix > Focus)

If your picture is a little soft, use Auto Focus to sharpen it just a bit, or apply the effect a few times. On the other hand, if your picture is a bit too sharp, soften it using Blur.

Rotate (Enhance > Quick Fix > Rotate)

If you want to rotate a picture, like making a vertical picture horizontal, choose Rotate.

Hue/Saturation (Enhance > Adjust Color > Hue/Saturation)

We met the Hue/Saturation Tool under the Quick Fix menu on the previous page. Here you will notice the addition of manipulating each color individually under the Edit button. Hue/Saturation helps change the color in a picture. Let's look at Saturation first.

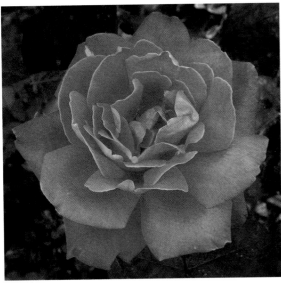

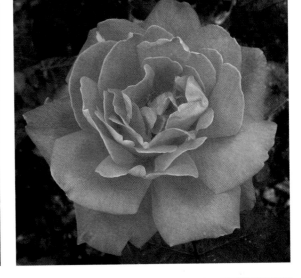

⇑ The Saturation slider lets us increase or decrease the saturation (color intensity) of an image. Here's my original image.

↗ Here's the result of moving the triangle on the Saturation slider halfway to the left. Now we have a softer, less saturated image.

⇒ Now I've moved the triangle on the Saturation slider about halfway to the right. The image is much more intensely saturated.

Hue (the color) in a picture can be fun to play around with.

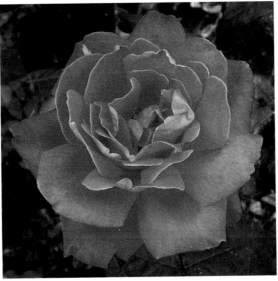

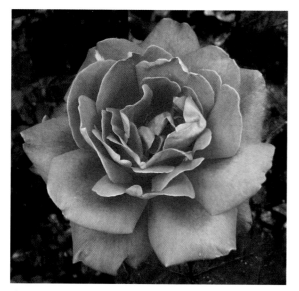

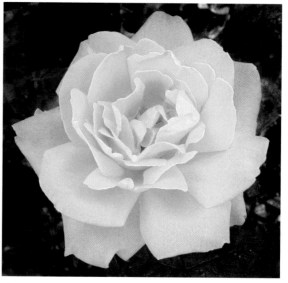

⇑ Here's the effect on my original image of moving the triangle on the Hue slider almost all the way to the left.

⇑ Look what happened to my picture when I moved the Hue slider almost all the way to the right.

Remove Color (Enhance > Adjust Color > Remove Color)

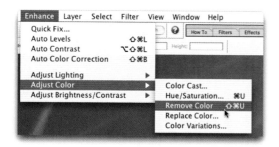

Want to try your hand at creating a black-and-white image from a color file? You can do that in a flash under Enhance by selecting Adjust Color > Remove Color. Here's the effect.

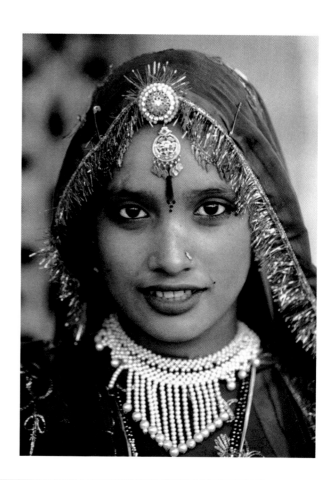

Replace Color (Enhance > Adjust Color > Replace Color)

In Photoshop Elements, it's easy to change a color in a picture by using Replace Color.

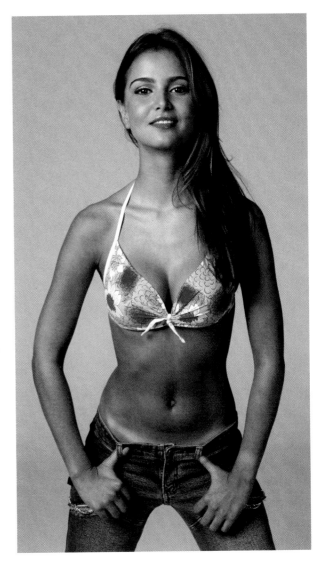

⇒ Here's my original picture.

⇒ When you select Enhance > Adjust Color > Replace Color, a dialog box opens presenting several choices. One choice is how to view the image. I chose Image in this example.

The next step is to move your cursor into the area you want to change. When you do, your cursor becomes an Eyedropper icon. Next, click on the color you want to replace. In this example, I clicked on the background.

⇒ To replace the color, move the sliders until you see the color you want. Then click OK.

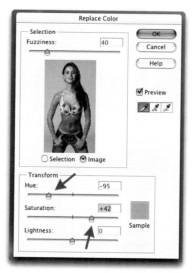

⇓ The background color has been replaced.

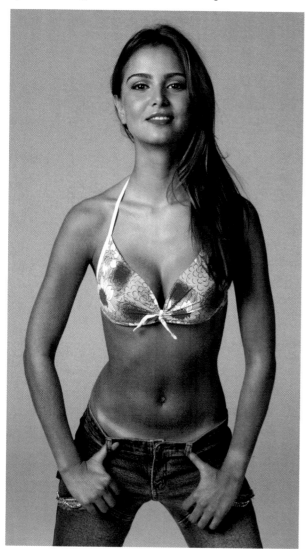

Color Variations (Enhance > Adjust Color > Color Variations)

Color Variations is another Enhancement that you may want to experiment with. It offers a preselected set of Hue/Saturation combinations in a single overview.

⇒ For this Enhancement, I'll use a picture of a performer I photographed in Guanajuato, Mexico.

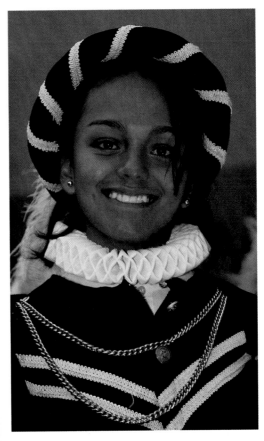

⇓ When we go to Color Variations, this dialog box opens. As you can see, there are many options for changing the color and brightness of an image, as well as options for making those adjustments to the Midtones, Shadows, and Highlights in a picture. We can also control the Saturation and the Amount of the effect.

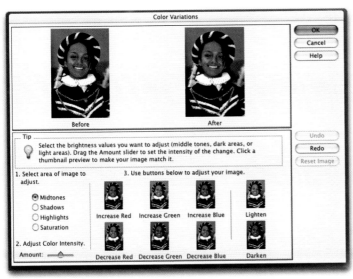

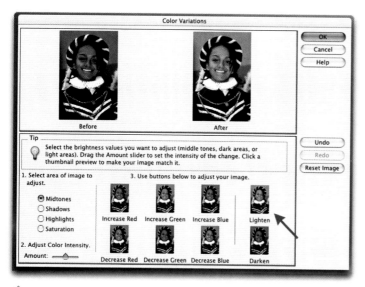

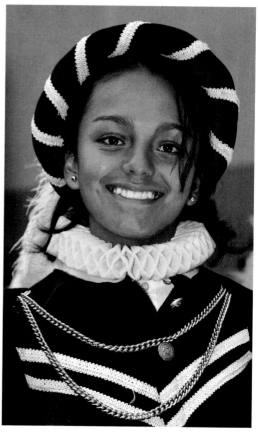

⇑ For this picture, I simply adjusted the Brightness.

⇒ Here is my adjusted picture, just a touch lighter than my original.

Levels (Enhance > Adjust Brightness/ Contrast > Levels or Command L)

Levels is a powerful way to enhance and improve our pictures, especially when they are underexposed.

⇓ Here are the histograms for my picture of the snorkeler in the Maldives on the opposite page. The

histogram with the red arrows shows that my pictures lack some highlights (right) and shadows (left). The histogram with the blue arrows shows how I moved the sliders to "add back" the highlights and shadows.

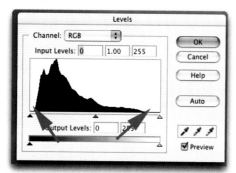
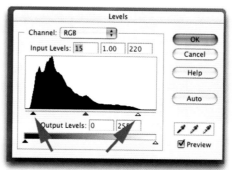

⇓ As you can see in this before-and-after set, adjusting Levels enhanced my original picture.

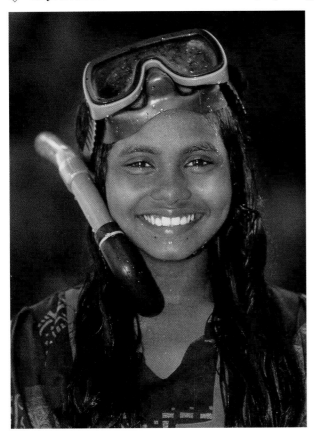
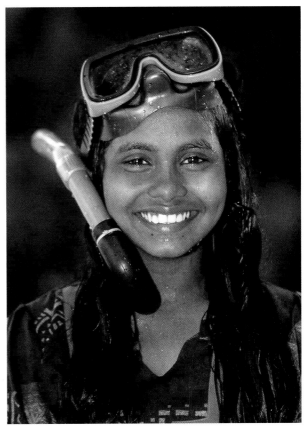

Layer (Layer)

Our next stop in this Menu Bar tour is the Layer menu. Throughout the upcoming Workshop section of this book you will see that Layers greatly expands our digital imaging horizons. Briefly, Layers lets us put two images on top of one another.

⇐ To view the layers in your image, go to Window > Layers. When the Layers dialog box is open, we can rename a layer by clicking on it and typing in a new title for our image. On the next page you will see how I changed the default "Background" to "Flowers."

⇒ In the Layers dialog box, we can choose the type of layer we want to add. Here's a look at all the layer types that are available when we click on Layer Type.

⇒ After dragging my renamed Flower Layer to the Create New Layer icon (my blue arrow), I selected Multiply from the Layer types (my red arrow).

⇒ A Multiply Layer darkened a picture I took of some flowers at the Bronx Botanical Garden. The original is overexposed (for teaching purposes). By using a Multiply Layer, I darkened the image for a more pleasing effect. Try this technique on your slightly overexposed pictures. Experiment with the other Layer types to see how they can enhance your pictures.

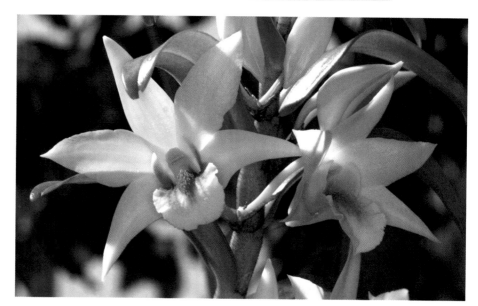

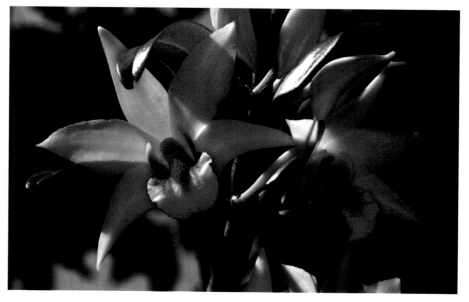

Filter (Filter in Main Menu or Menu Tab Dock > Filter)

Filters offer instant gratification on the Menu. Open an image. Then reach the filters one of two ways.

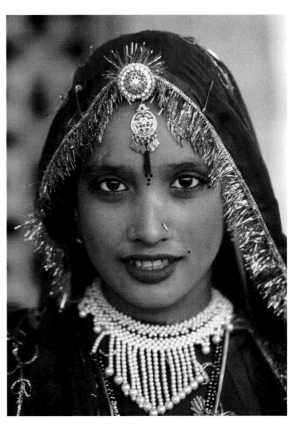

⇐ Go to Filter in the Main Menu.

⇒ Or click on the Filter tab in the Menu Dock. Scroll up and down until you find the filter you want, then select it by clicking on it. When you do, a

dialog box opens presenting different creative options. Experiment with your choices, and when you see what you like, click OK. Here I used Filter > Sketch > Note Paper.

⇒ When applying some filters, the foreground color affects the filter's effect. In this example, I picked Light Cyan in Swatches by going to Window > Color Swatches and then clicking on that color swatch.

Effects (Menu Tab Dock > Effects)

Effects palettes are fun to use, too. After clicking a tab in the dock and selecting an Effect, simply click Apply. With this Effect, I first selected an area around the girl's face (using the Elliptical Marquee Tool in the Tool Bar) and then chose Vignette Selection from the Effects palette.

Undo History (Menu Tab Dock > Undo History)

I never make mistakes when editing my pictures in Elements. Only kidding! I do make mistakes, and I have even been known to change my mind about a filter, effect, or enhancement.

When I do goof or have a new idea, it's easy to go back in time, so to speak, by using the Undo History feature.

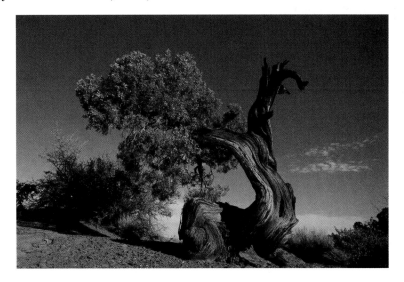

⇒ Here is a before-and-after example of a juniper tree I photographed at Dead Horse Point State Park, Utah. When working on the image, I open the Undo History palette on my desktop to make removing a change easy.

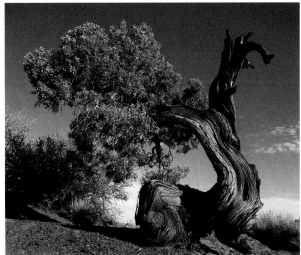

⇑ One way to get to Undo History is to go to Window > Undo History on the Menu Bar.

⇐ Another way to get there is to click on the Undo History tab in the Menu Tab Dock. To go back in time, to a previous enhancement step, all you have to do is click on that step and begin from there. As you can see from this screen shot, the steps I used to enhance my picture were: Crop, Levels, Burn Tool, Dodge Tool and Hue/Saturation.

I hope you enjoyed this introduction to the Tool Bar, Menu Bar, and Tab Dock. In the next section, we will get to the heart of the book, the workshops on specific image-editing techniques.

Enter Elements 3.0

Toward the end of writing this book, during which I was using Photoshop Elements 2.0 to illustrate all of my tips and techniques, I received an e-mail announcing the introduction of Elements 3.0. My first thought was, Oh, my God! I'll have to redo most of the book, changing all the screen shots and rewriting much of the text. Naturally, I could not wait to get my hands on the program to assess my additional work.

When Elements 3.0 arrived I was relieved to find that all the lessons—the heart of this book—would run with just a few minor editorial changes and the addition of some new screen shots.

In addition, by adding this chapter, I have expanded my original intent to allow users of both Elements 3.0 and Elements 2.0 to learn from and enjoy this book. Keeping this in mind, the updated text offers tips for Elements 2.0 and 3.0 users.

On the previous pages you read about Elements 2.0. Now, let's take a look at some of the new features that can be found in Elements 3.0.

New Front End

⇊ The first thing that's different about Elements 3.0 is that the interface (opening window) looks different from the previous version. Basically, the start-up screen lets you choose to make image adjustments from either the Standard Edit or Smart Fix interface. Here's a look at the Standard Edit dialog window. For more serious work

and for more control, Standard Edit is the way to go. Although some of the new version's features may be found in different places, they function exactly the same way as they do in Elements 2.0.

Smart Fix (Enhance > Adjust Smart Fix)

⇓ The Smart Fix window offers a quick fix to an image by using various slider controls. If you are in a hurry to make an adjustment, check out Smart Fix. You can also move back and forth between the Standard Edit and Smart Fix controls by simply clicking on their respective buttons in a tab that's located in the upper right-hand corner of the screen.

In both windows you'll notice that the working image is also displayed in a Photo Bin at the bottom of the screen, another addition to the Elements 3.0 interface. When working on several images at one time, thumbnails of each of the images will be displayed in the Photo Bin. Clicking on any one of the thumbnails gives you instant access to the image.

New Tools and a Redesigned Tool Bar

⇒ Two new tools have been added to the redesigned Tool Bar: the Cookie Cutter Tool and two different Healing Brush Tools (Spot Healing and Healing Brush). Both of these latter tools work similar to the Clone Stamp Tool that's found in Elements 2.0 and are useful for healing (fixing) blemishes and marks on a portrait subject's face. The Spot Healing Brush Tool is a one-click tool (just click over a spot with a brush that is larger than the spot), and the Healing Brush Tool works much like the Clone Stamp Tool (you pick up the texture from one area and paste it over the area to be fixed). But it may be a little easier to use because it tries to make the colors match. This tool is not perfect, especially when you close to an area of really different color or tone. As before, pick the tool that fits the repair you want to make.

Cookie Cutter Tool (Q)

⇒ We find many different shapes (hearts, dogs, cats, butterflies, and so on) in the Cookie Cutter Tool that we can use to frame or cut out objects in a photograph. Personally, I think some of the "cookies" are a bit silly. But, there are some clever features of the Cookie Cutter Tool, especially the digital frames that we can use to frame a photograph artistically. Here I dressed up a picture of a jaguar using one of the frames.

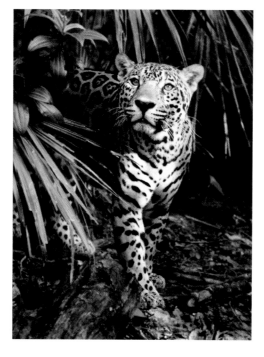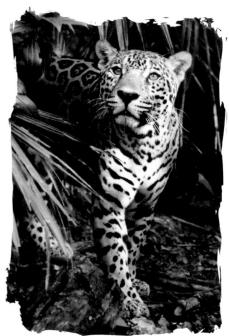

Spot Healing Brush Tool (J)

⇒ Here's an example of how I used the Spot Healing Brush Tool to remove a few blemishes from this monk's face.

Let's move on to some new features that will be found in the Menu Bar.

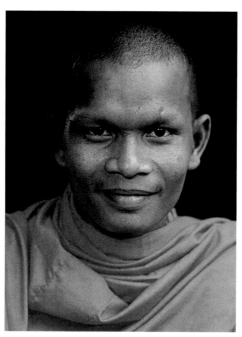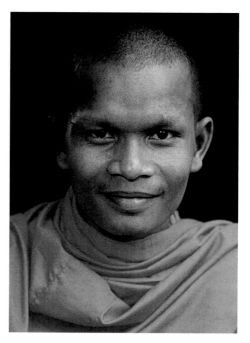

Shadows/Highlights Control (Enhance > Adjust Lighting > Shadows/Highlights)

⇓ Under Enhance, we find Adjust Lighting and a new feature, Shadows/Highlights, which is similar to a command found in Adobe Photoshop CS. By clicking and moving Shadow and Highlight sliders, you can individually control all of the shadows and highlights of the scene. In the Shadows/Highlights dialog box there is also a slider to control Midtone Contrast. Sure, Levels (and Curves in Photoshop CS) offers more precise control over shadows and highlights, especially when you are working on adjustment layers and selectively erasing areas of an image. But the Shadows/Highlights control makes the process easier.

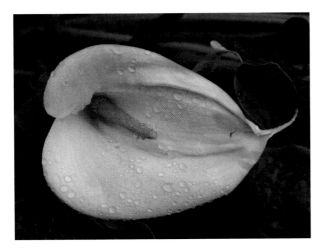
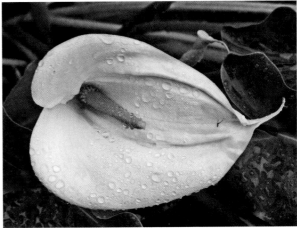

⇑ In this example, I lightened the shadow area (green leaves) without brightening the white flower.

Now let's take a look at two new filters in Elements 3.0.

Photo Filter (Filter > Adjustments > Photo Filter)

When we go to Filter > Adjustments, we find that a filter from
Photoshop CS, Photo Filter, is now included in Elements 3.0. At the click
of a mouse (or tap of a WACOM stylus on the tablet), you can add one of
18 photographic-style filters to a picture. Warming, cooling, sepia, red,
yellow, and green are just a few of the digital filters, all of which can be
applied to an image in different densities via the Density slider, a k a the
Fade command in Adobe Photoshop CS.

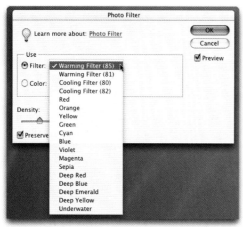

⇓ Let's take a look at how just two of these filters
affected my original photograph of Bryce Canyon.

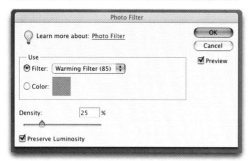

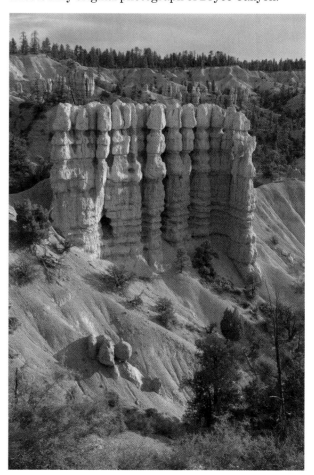

⇑ Here I used the Warming Filter 85 filter to "warm up" the picture, simulating the light of late afternoon or early morning much the way that I would have attached a #85 camera filter to the front of my camera. Doing it digitally gives me more control over the final effect.

⇑ Here I used the Cooling Filter 80 to "cool off" my picture, creating the impression that the photograph was taken by moonlight.

Reduce Noise (Filter > Noise > Reduce Noise)

⇒ Digital noise (or grain in film) shows up more prominently in shadow areas, especially when your digital camera is set at higher ISO settings. It's also more evident in images taken with low- and mid-range digital cameras that have physically smaller imaging chips. In this picture of a cowgirl, I wanted to remove the noise from the darker area in the background.

⇓ Once this Digital Noise dialog box is opened, you have access to three settings for reducing the digital noise in a particular digital file: Strength, Preserve Detail, and Reduce Color Noise. Due to printing limitations, you may not be able to see how effectively this filter works in these before-and-after screen shots. However, when making inkjet prints, I am sure you'll see the benefits of this tool.

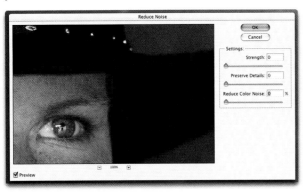

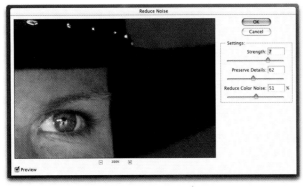

Layers Palette

Well, what goes down must go up, I guess. In the Elements 2.0 Layers palette, we drag down to create a new layer, put a layer in the trash, and so on. In the Elements 3.0 Layers palette, we drag the mouse up to a line of icons. Oh, well, I guess the folks at Adobe felt we needed a bit more exercise when working in Layers, but this arrangement does seem to make more sense.

The Layers palette is tucked away, along with a few others in the Palette Bin that you can choose to see or hide. When the bin is open it hogs some of the screen's real estate unless you are using widescreen monitors such as those available from Apple Computer and Samsung.

That's a quick look at the new features of Elements 3.0. If you have this version of Adobe Photoshop Elements, be sure to play around with all of the tools, enhancements, and filters so you can become familiar with the creative possibilities. As I mentioned at the beginning of this lesson, you'll be able to work through (play with) all the lessons in this book using either program.

PART III
The Digital Imaging Workshops

You are about to enter the "main course" of this book, the step-by-step workshops that I've prepared especially for you. Each workshop tackles a specific image enhancement technique that I have found both useful and popular in the workshops I teach.

As examples of the kinds of techniques you'll learn, take a look at these two before-and-after sets of pictures, which are not on the CD-ROM.

⇓ By cropping, adjusting the exposure, increasing the canvas size, and then adding some type and a digital frame, I transformed a snapshot I took in Botswana. You will be able to follow each workshop step by manipulating the work images included on the enclosed CD-ROM. Crop and Type, which affect selected areas within an image, are found on the Tool Bar. Size and Frame adjust an entire image area and are found on the Menu Bar and Tab Dock, respectively.

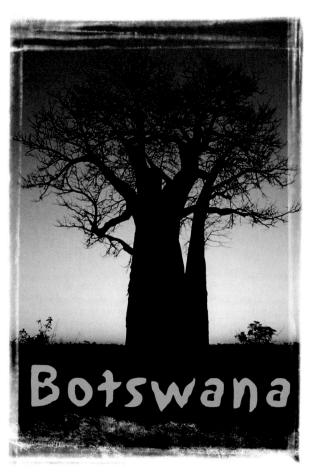

⇊ In this example, too, cropping and adjusting the exposure turned a simple snapshot into a much more vibrant picture. But we will do much more than that in this section.

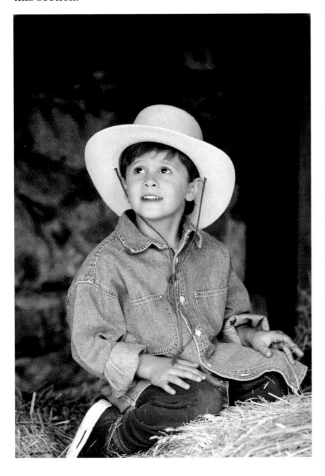
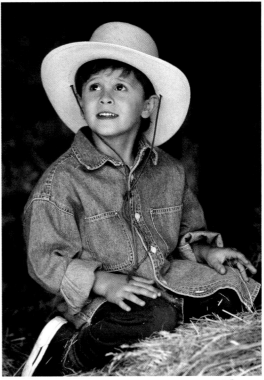

Here's how to use this Workshop section.

First, read "Workshop #1: Diagnose the Image." We will analyze a picture from a technical standpoint—as opposed to an aesthetic standpoint. We will examine how important settings, including Levels, Black Point, Gray Point, and White Point, can be used to enhance a picture.

Second, glance over each workshop to get an idea of how I enhanced a picture, and think about how you can create the same effect—or perhaps an even more pleasing one.

Third, copy the Work Image folder from the CD-ROM onto your hard drive and work on those images. That way, the images will open more quickly and be savable to your computer. In addition, if you work on the copied images and make a mistake on the Work Image file, you can go back to the CD-ROM and recopy the picture to your hard drive and start again.

Fourth, when reading a lesson, open the corresponding Work Image (or images). With the Work Image opened on your monitor and the book on your desktop, it will be easy to follow the process from start to finish.

When you are finished with the workshop, keep playing around with the final image. Perhaps you will see a different Filter, Effect, Levels, or Brightness/Contrast setting that can enhance the image in ways you like better than what I did in the lesson. If you do, e-mail me a 72 PPI image at rick@ricksammon.com.

All of the tools and enhancements in Elements are at your fingertips. All you have to do is add your imagination.

Before you open your own photographic images, however, here is a very important tip: Never work on an original image. If you make changes to a picture and save it with the same name, your original is lost forever. So, the best thing to do is to make a copy of a picture, save it with a different file name, and work on that copy.

Diagnose the Image

Finding the Mountain Range of Tones in Your Image

Before we can dive into the digital darkroom, we need a basic understanding of the brightness range of a digital file. We also need to understand how we can or cannot adjust the image's highlights and shadows.

We can work some magic with the tools in Elements, enhancing our pictures and fixing some mistakes. However, we cannot always perform miracles, as you'll see at the end of this lesson.

⇧ **Work Image #1: Volkswagen** (Find all work images on the CD-ROM in the back of the book.) On an overcast morning in San Miguel de Allende, Mexico, I intentionally underexposed the shot of this red VW Beetle by about 1/4 of a stop, as I often do. Underexposing the scene prevents the highlights, such as the headlights and reflections on the car's fender, from being washed out. Yet the scene looks flat because the clouded sky removed the light. Furthermore, underexposing added to the flatness, even if it helps the bright areas from white out.

We can ask several questions about this image: What points in the image are the darkest? How dark are the darkest blacks? How much of the image's important

details lie in the darker shadow or low-key areas? What points in the image are the brightest? How bright are the brightest whites? How much of the image's important details lie in the brighter or high key areas? Therefore, how many midtones lie in-between the image's darkest shadows and brightest highlights?

First, we should use our own eyes to scan an image for the answers. And then we can go to the most helpful diagnostic Menu item in Elements to see a graph of the answers.

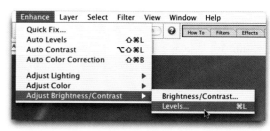

⇒ The diagnostic item called Levels lets us precisely determine and adjust the brightness, color, and contrast of an image. To open Levels, go to the Menu Bar and then go to Enhance > Adjust Brightness/Contrast > Levels.

⇒ When you open the Levels dialog box, you see what's called a histogram. The histogram has nothing to do with the history of an image, the steps we take in adjusting and enhancing a picture. The histogram, the "mountain range" we see, shows us the brightness range of the scene—with the highlights on the right side of the mountain range and the shadows on the left side of the mountain range. The taller each vertical black bar, the more pixels within the entire image are found in the brightness location on the horizontal axis. This histogram shows that the image lacks highlights and shadows but has plenty of midtones, which is why the mountain range is high in the center of the histogram window.

⇒ Following is a more detailed explanation of a histogram, which you can find by going to the Help item on the Menu Bar at the top of your monitor. Click on Help and you are connected to the Adobe Web site on the Internet. Follow the on-screen instructions to find the answers to many of your questions, if not all.

According to the Adobe Web site:

A histogram illustrates how pixels in an image are distributed by graphing the number of pixels at each color intensity level. Histograms can show you whether the image contains enough detail in the shadows (shown in the left part of the histogram), midtones (shown in the middle), and highlights (shown in the right part). You can use this information to make more precise corrections.

The histogram also gives a quick picture of the tonal range of the image, or the image key type. A low-key image has detail concentrated in the shadows; a high-key image has detail concentrated in the highlights; and an average-key image has detail concentrated in the midtones. An image with full tonal range has a high number of pixels in all areas.

⇒ In our Levels dialog box we see three small Eyedropper icons. From left to right, they are used for setting the Black Point (darkest shadow), Gray Point, and the White Point (brightest highlight) for an image. Click on the Eyedropper representing the brightness point you want to shift. Move the Eyedropper cursor into an image, click on the appropriate area of the image that is your new Black, Gray, or White Point, respectively. Click on OK. Levels automatically recalibrates the image tones so the tone of area you chose is the new Black, Gray, or White Point, with all the other tones shifted up or down accordingly.

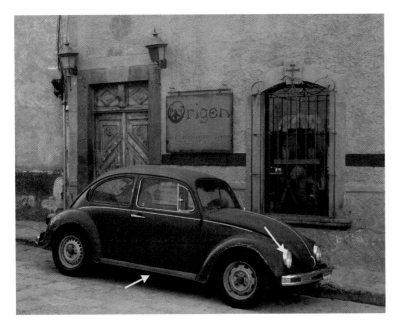

⇐ The key to using the Eyedroppers is to "see" the different Points. For this image, I guessed the highlights on the rim were located around one of the headlights (White Point) and the shadow area beneath the car (Black Point).

⇒ My guesswork worked pretty well. This is how my image was enhanced after following the above procedure.

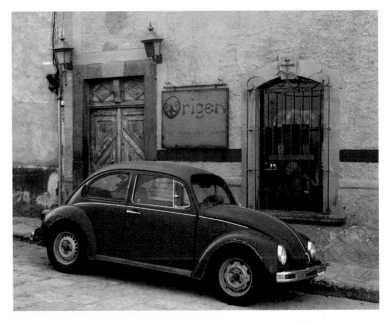

⇒ Here's the catch. If you select incorrect White and Black Points, shown here by my arrows, the results can create colors far from accurate and less than pleasing.

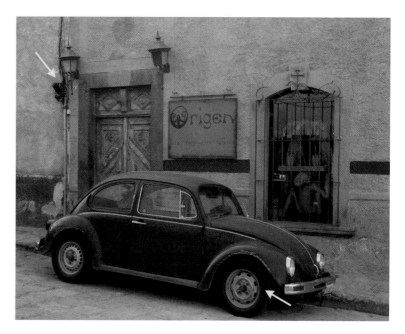

⇘ Here's what happened when I selected the wrong Points. You may be asking why we omitted manipulating the Gray Point. Seeing the Gray Point in an image is even harder than determining the White Point. What is the absolute middle tone between the darkest shadow and brightest highlight? It's just a guess. So I always skip it. What's more, as you'll see in the next screen shot, there is a much better way to adjust the Levels of a picture.

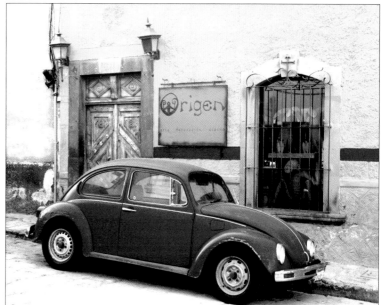

⇑ At the edges of the histogram window are two small triangles. These are the keys to adjusting an image, in my viewpoint. Here, they lie outside of the mountain range, just to its left and right.

⇒ Generally speaking (more on this in a moment), if you click on the triangles and move them inside of the mountain range on their respective sides, and then click OK, your image should be adjusted correctly.

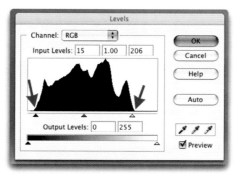

⇓ Voilà! This is how my image looks after being manually adjusted with the sliders in Levels.

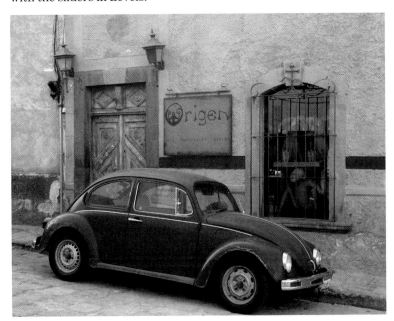

⇓ If we go back to the Levels dialog box, we now see that the mountain range covers a more even area of the histogram window. Our highlights and shadows have been recovered (in a sense).

⇑ But wait! I like pictures slightly dark. My wife likes them a little lighter. So, to darken the image a bit more, I moved the shadow slider on the left to a point inside the left or darker side of the mountain range.

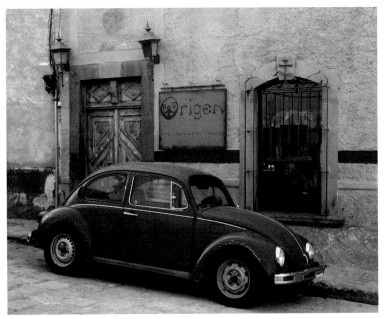

⇑ After I've made my custom adjustment, the image is more to my liking, but not to my wife's.

⇓ Let's take a look at another photograph from San Miguel de Allende.

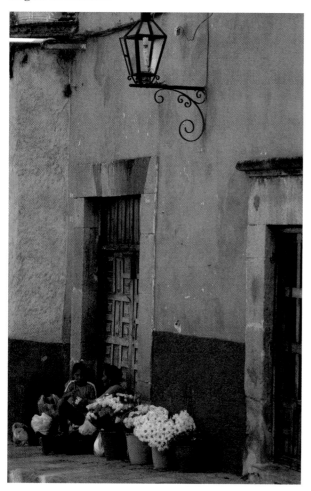

⇓ Looking at the histogram for this image, we see that the highlights and shadows are lacking, which can be easily fixed by moving the highlights triangle to just inside the right side of the mountain range.

⇓ Here's the adjusted image, with just a bit of highlight enhancement.

⇒ As I mentioned at the beginning of this lesson, we can't always work miracles with Elements. This street scene showing a church dome in San Miguel de Allende illustrates that point.

⇓ If we look at the histogram for this image, we see two main "peaks," a tall peak on the left for the strong shadows, and the smaller peak slightly off-center toward the highlight area of the histogram.

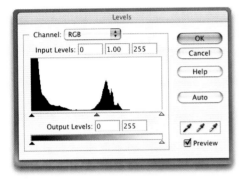

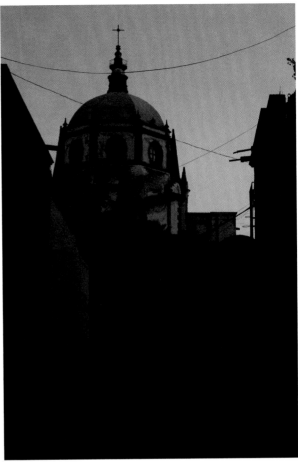

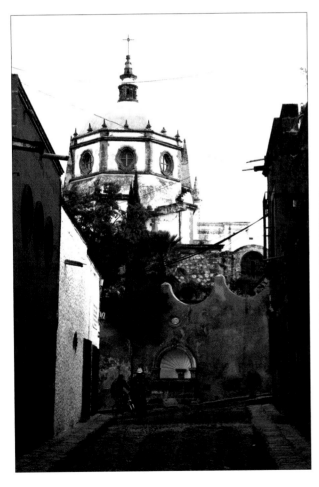

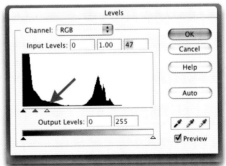

⇑ To "pull" (try to rescue) the data out of the shadow area, we'd have to move the highlight slider to the point shown, way too far to the left side of the histogram.

⇐ Here's the result of that maneuver in Levels. Not great.

⇒ Ah, that's more like it. Now we can see clearly into the shadows. Plus, our highlights are not washed out. How did I work this magic? Well, as you can see, it's not the same picture. To get a picture with a better tonal range, I had to wait for another day and shoot at a different time, when there was less of a contrast range between the brightness values of the scene.

↘ Here's a look at the histogram for the new image taken on the next day. As you can see, only a slight adjustment is needed.

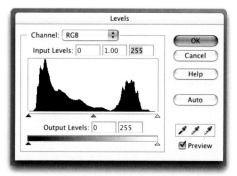

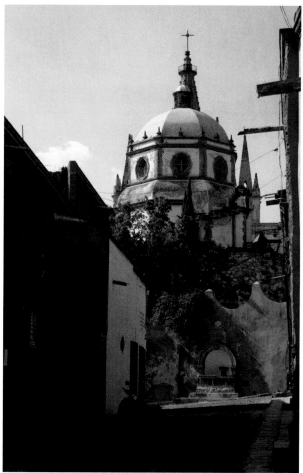

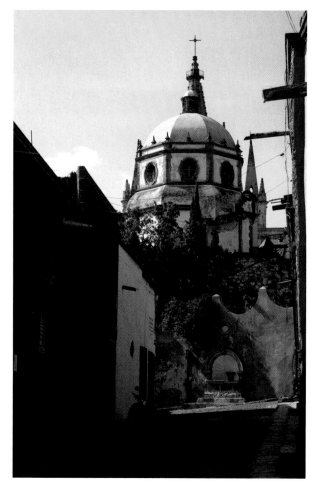

⇐ After adjusting the histogram, my image has a bit more contrast. The adjustment is so slight that you may not be able to see it on this page (due to limitations in the printing process).

Summing up: Use the histogram for enhancing your images. But keep in mind that sometimes you need to wait for the light to change or to recompose an image. You also might have to reduce the contrast range of a scene by adding a flash or by using a reflector or diffuser at the time you take the picture. Don't skip "Start in Your Camera" in Part I.

And keep in mind that gorgeous photographs full of meaning are possible that are very low key or very high key or that contain a narrow range of tones in between.

Adjustment Layer

Place Each Alteration on Its Own Layer

When working on your images, it's best to make changes on Adjustment Layers, rather than directly on the image. That way, the picture is left untouched and the changes are applied to a separate layer. You can trash an Adjustment Layer if you don't like what you did. Or you can go back to a layer and make additional changes at a later date. Remember, to preserve your added layers, save your picture as a TIFF or PSD (Photoshop document) file.

Let's take quick look at Adjustment Layers.

⇧ **Work Image #2: Turret Arch** We'll use a picture of a Turret Arch I photographed in Arches National Park, Utah.

⇒ When we open an image and then open the Layers palette, by clicking on the Layers tab in the Menu Tab Dock, we see that we only have one layer.

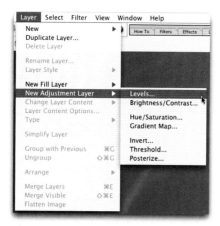

⇑ To see the Adjustment Layers options, go to Layers > New Adjustment Layer. Here I have chosen to create a Levels Adjustment Layer.

⇓ After selecting the type of Adjustment Layer we want to create, we get another dialog box that lets us name the Layer. In this example I just clicked OK.

⇒ After clicking OK, an Adjustment options dialog box opens in which we can make our enhancements. Here, in the Layers dialog box, we see that a new Levels Adjustment Layer has been created.

⇓ Here's a screen of the Levels dialog box, with the Levels already adjusted.

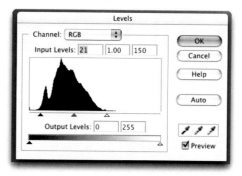

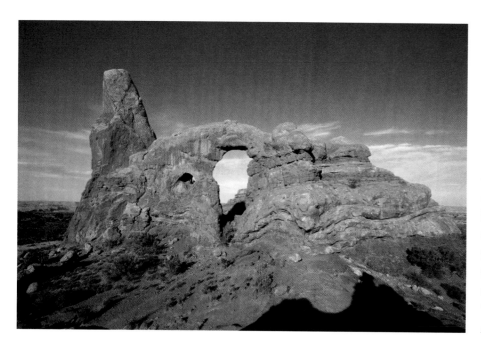

⇐ Adjusting the Levels created a more dramatic image. You'd see the same effect if you made the adjustments directly on the image, but here you are looking at the image "through" the top Adjustment Layer.

⇒ You can create multiple Adjustment Layers. My next step was to create a Hue/ Saturation Adjustment Layer following the procedure outlined above.

As you can see from the above screen shot, I now have three Layers (two Adjustment Layers and my working picture).

⇒ Next to my Layers dialog box is the Hue/Saturation dialog box.

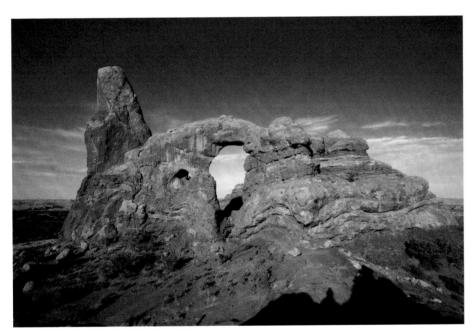

⇑ This image is the result of increasing the Saturation on the Adjustment Layer.

Now that we've taken a look at Adjustments Layers, and we know that Adjustment Layers are the best way to make adjustments to an image, we'll move away from them for the remaining workshops to save time and space.

New Layers

Use Layers to Create a Montage

LEARN ABOUT

Image Resolution

Layers

Renaming a Layer

Erasing

Layer Opacity

Turning Off a Layer

For newcomers to Adobe Photoshop Elements, Layers can be a bit confusing. However, it's actually quite a simple concept. For example, imagine you are holding two 8×10-inch prints, one in each hand. One picture is of a sunset and the other is of a tiger. If you hold one photo on top of the other and perfectly align them, you'd have two layers of pictures. That's the same concept used in Layers: One image is placed on top of another, and perhaps another and another and so on.

In this lesson we'll learn how to create a very basic montage using layers. This lesson will help prepare us for working with layers in upcoming workshops.

⇓ **Work Image #3A: Sunset** and **Work Image #3B: Tiger** A montage may comprise several images. For this lesson, we will work with only two, one of a sunset and one of a tiger.

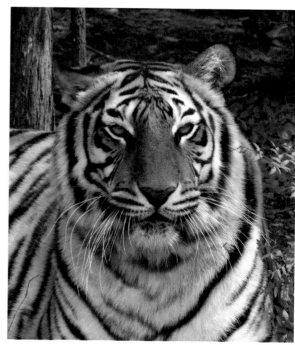

⇒ Each image to be used in a montage should be exactly the same resolution as the others. In this example, I set the resolution of both my pictures to 300 pixels per inch, or PPI. (See the "Must-Know Digital Information" section for more information.) If the resolution is different, a picture with the same Width and Height as another picture with the same Width and Height but with a different Resolution will be a different size when applied as a layer—because the pixels per inch don't match up. I set the resolution at 300 because I intended to make an enlargement. On the Work Image, the resolution is 200 PPI.

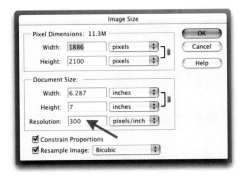

So, before you begin, examine the resolution of your pictures by going to Image > Resize > Image Size. In that dialog box, look at the "Document Size" data area. If the pictures exhibit different resolutions, note the image with the higher resolution. For most printed images, 240 PPI up to 300 PPI is ample resolution to ensure crisp prints. Generally, if both images came from the same camera set to the same resolution, the images should exhibit similar resolution and blend well. If both were saved to a storage medium such as your computer's hard drive, but came from different sources, they may have rather different resolutions. For example, most images posted to Internet Web pages contain circa 72 pixels per inch because that is the resolution of most computer screens. But such a low-resolution image will not blend seamlessly with a 240 PPI image from your camera.

Speaking of low-resolution images, you may be wondering why my screen shots, taken off my monitor with a program called Snapz X Pro, look nice and sharp in this book. Well, it's because they are shrunk down to smaller size, which makes any picture look sharper.

⇓ In this screen shot, after both images were opened and placed next to each other, you can see that both pictures are the same size, because the resolutions and the dimensions are the same. When creating a montage, keeping both images open is important. In doing so, you can see the relationship between the size of the images, which, as you will see, changes as you move along in this process.

⇒ When you open an image, the Layer will be locked, as shown in the Layers palette. In this example, we want to move the tiger photograph into the sunset photograph, so that's why we are unlocking this image.

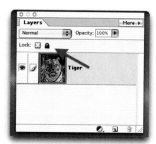

⇓ To unlock a Layer and rename it, click on the highlighted area. That opens another dialog box. After you type in a new name and click OK, your Layer will be renamed and unlocked.

⇓ The next step is to determine how much of one image you want in the other image, as well as the size of the image. Play around with the Height and Width of the tiger photo to determine how large you want the animal in the montage. I left the size of the tiger photo untouched.

The next step is to use the Move Tool to move the tiger image into the sunset image. Simply click in the tiger image and, while holding down your mouse button, drag the image over to the sunset image. In this screen shot, you can see the result, with the sunset image showing on the left and right sides of the frame. When moving an image, if you don't like where you placed the dragged image, don't worry.

⇓ Using the Move Tool, you can move the dragged image to any position in the target image. By the way, when you drag one image into another, you automatically create a Layer. So, at this point, you are working with two Layers.

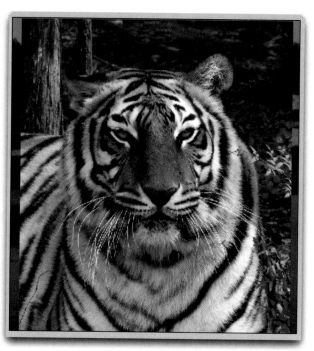

⇑ The next step is to erase the areas of the picture on the top Layer that you don't want—revealing the Layer below. In this case, I wanted to erase most of the area around the tiger's head. Here's the key to making a smooth transition between erased and nonerased areas (making the transition less noticeable): As you move in toward the subject, reduce the Eraser's Opacity on the Menu Bar. This will reduce the speed at which you erase, as well as the amount of erasing. You may want to erase more or less of the tiger's body.

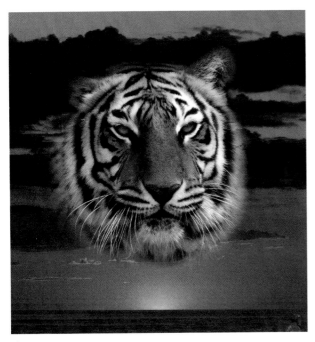

⇑ Here's the result of my dragging and careful erasing.

⇒ What's creative about a Layer is that you can reduce its Opacity, which reveals more of the layer below. In this example, I wanted a more subtle tiger image in my montage. So, I reduced that Layer's Opacity, by clicking on the slider and dragging it to the left, to 70 percent.

 To make a Layer invisible, click on the tiny eye. This toggle switch turns off a Layer. Click again to reveal it.

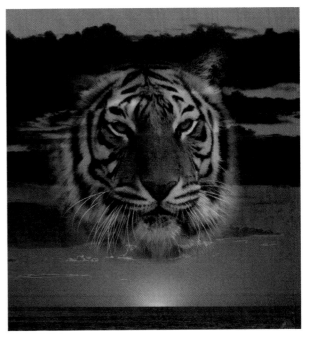

⇒ And here's what happened when I reduced the Opacity to 50 percent.

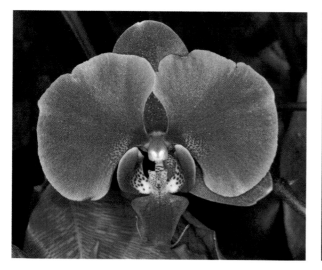

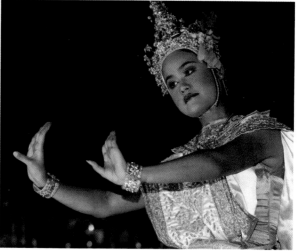

⇒ Here's perhaps a more subtle montage, combining a picture of an orchid and a dancer in Bangkok, Thailand. For this montage, I reduced the Opacity of the top Layer, the dancer, to around 20 percent, for a very, very subtle effect. Then, after I used the Elliptical Marquee Tool, I use the Vignette Selection effect (found on the Menu Tab Dock) for yet another effect.

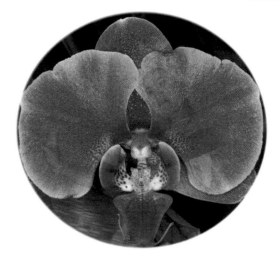

⇐ Here's a montage I created using three pictures of a manta ray, whale shark, and clouds. I call this one "Sky Diving." When making a montage, you can use multiple pictures and layers.

Experiment with the Opacity. And have fun creating your own version of this montage by experimenting not only with the Opacity, but with the placement and size of the images.

Boost Color and Contrast

How to Turn a Drab Shot into a Fab Photo

The digital darkroom has changed the way we take pictures. Knowing that we can turn a drab photo into a more dramatic image, we capture subjects and scenes with our cameras that we might not normally have photographed.

In this workshop, we will go through the process of turning two lackluster photographs into images that pop with color and contrast.

⟸ Work Image #4A: Cheetah We'll begin with a picture of a cheetah photographed at the Fossil Rim Wildlife Center in Glen Rose, Texas. The day was overcast and the animal was in the shade. Those conditions produced a dull photo.

To boost the color, contrast, and detail in the scene, let's use Levels. You get there by going to Enhance on the Menu Bar and then by going to Adjust Brightness/Contrast > Levels.

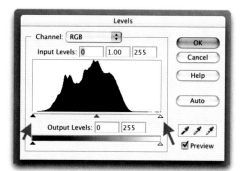

⇑ Levels shows the brightness range of the picture: shadow areas on the left and highlights on the right. My picture lacks shadow areas and highlights, which is why the brightness "mountain" does not extend to the edges of the histogram.

⇓ To "add back" the shadow/highlight areas, click on the little triangles on the slider and move each inward slightly to a point just inside the mountain. Then click OK.

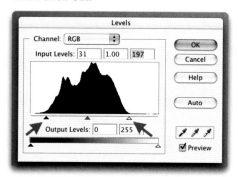

⇑ If we were to open Levels again, we'd see that the brightness range of the scene has been evened out, and that we now have complete shadow/highlight areas.

⇓ Here's my image after Levels was applied.

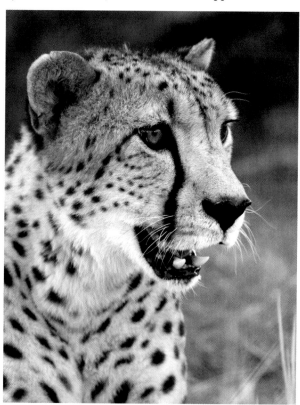

⇓ For more impact, I cropped my picture, filling the frame with the subject. Try playing around with cropping.

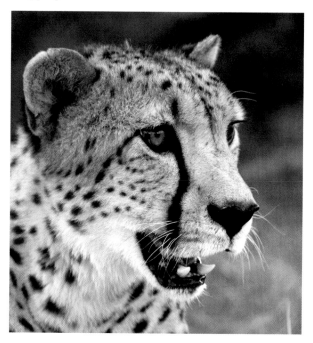

When you look through your camera's viewfinder, it's a good idea to scan around the edges to see if there are any distracting elements in the scene. Try that when you have a picture on your monitor, too. Here we see a distracting blade of grass in the bottom right part of the screen. I know it's a small detail, but detail is what photography is all about.

⇒ Using the Clone Stamp Tool, pick up a nearby area and paste it over the blade of grass, eliminating it from the image.

⇓ Most photographers strive for the sharpest possible in-camera photograph for the most realistic image. I'm one of them, always using the lowest possible ISO setting for the existing light conditions and shooting in the RAW mode. But I also like to experiment with filters to take some of the reality out of the scene. For my cheetah photo, I experimented with the Film Grain Filter (Filter > Artistic > Film Grain), moving the sliders back and forth to see the different effects. Now it's your turn to experiment with the Film Grain Filter.

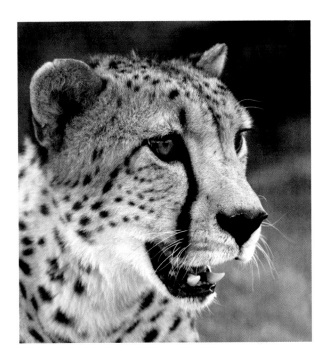

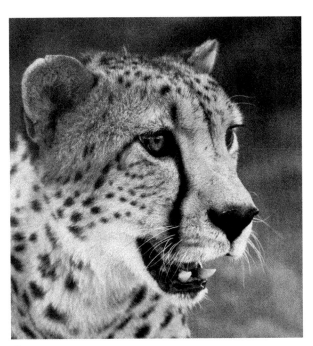

⇑ This is how the Film Grain Filter transformed my sharp shot.

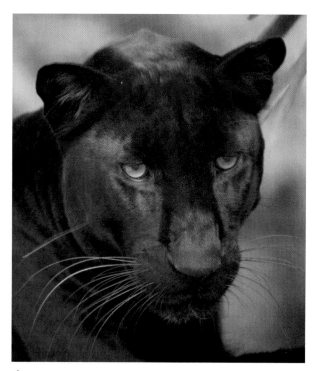

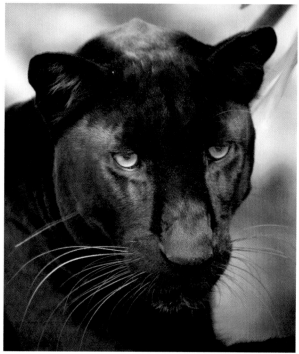

 Work Image #4B: Black Leopard In the next example, we'll take a look at another drab shot. I photographed this leopard at Big Cat Rescue in Tampa, Florida.

↗ Using Levels, add more contrast and color to the picture.

⇒ Notice any difference between this picture and the previous one? Well, I used the Dodge Tool to darken the overexposed area on the top of the animal's head. Go to the Tool Bar, select the Dodge Tool, and try darkening the area yourself.

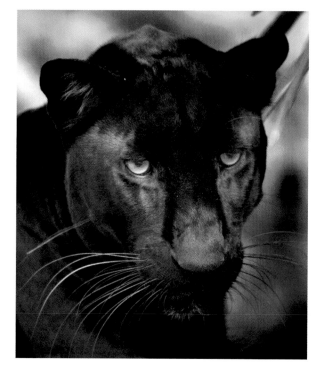

The picture is a bit soft. However, we only want to sharpen the animal's face. If we sharpen the entire image area, we'll get more digital noise in the background. What's more, sharpening only the animal's face will draw more attention to it in our final image. We could use the Sharpen Tool in the Tool Bar (Filter > Sharpen > Sharpen), but there's a much better technique. Here's how.

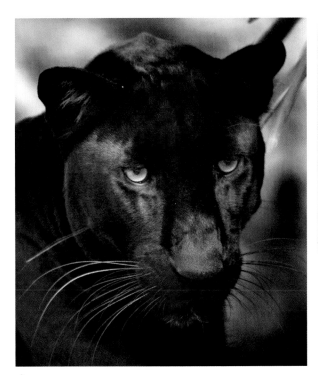

↑ Make a duplicate layer by dragging down the background layer to the Create New Layer icon at the bottom of the Layers palette. (Elements 3.0 users: Pull up to the Create New Layer icon. See "Warm-up #3: Enter Elements 3.0.")

↓ Now turn off the top Layer by clicking on the eye icon next to the image. The eye icon will disappear. Now click on the bottom layer to make that your working layer.

Next go to Filter > Sharpen > Unsharp Mask. Click inside the image window and move the image around until you see the most important part of the image—the eyes, in this case.

↑ Play around with the sliders until you get the desired effect. I usually leave Radius and Threshold low and boost the Amount.

↓ The next step is to turn the top layer back on and turn the bottom layer off. In case you are wondering how the Layers window got into the picture area, I moved it from my desktop into the image area by clicking on the tab in the Layers palette (highlighted so you can see it) and then by dragging it into the image. This window will not show up in your final image.

I was now on the top, soft layer. To reveal the leopard's face on the sharp layer below, I selected my Eraser Tool from the Tool Bar and erased part of the animal's face. Turning off the bottom layer is not absolutely necessary, but it's a good technique for seeing what you are doing. Go through these steps and try this technique yourself.

⇒ Here is the sharpened image. But we are not done yet.

We want to draw more attention to the animal's eyes. We can do that by boosting the contrast of the eyes. That will take just a few more steps.

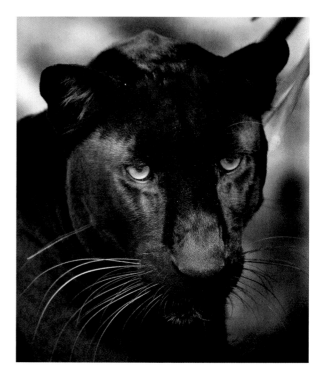

⇓ After flattening the image (Layer > Flatten Image), create two identical layers, as I did in the cheetah illustration, and begin work on the top layer. To select both eyes with the Elliptical Marquee Tool, first click on the Add to Selection icon on the Menu Bar at the top of the monitor. After doing that, circle both of the animal's eyes as I did. As you can see, part of the animal's fur will be selected. Don't worry, we'll fix that soon.

⇑ With both eyes selected, go to Enhance > Adjust Brightness/Contrast > Brightness/Contrast and increase the contrast.

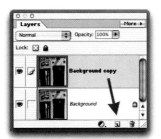

⇐ For this technique, we would normally not make a duplicate layer of our image. We'll do it here for a reason you'll shortly see. To make a duplicate layer, simply click on the background layer and drag it down to the Duplicate Layer icon at the bottom of the Layers palette. Make sure that you click on the top layer after you make a duplicate layer. That is your working layer.

⇐ Next, go to the Tool Bar and click on the Polygonal Lasso Tool from the fly-out menu.

⇒ Now it's time to select the window in which the conductor is standing. Begin by clicking on the top left corner. Then click on the bottom left corner, bottom right corner, top right corner, and back to the exact same point where you started. Your selection is complete, indicated by what we call "marching ants," dotted white lines.

To rescue the detail in the shadow area, we're going to use Levels.

⇒ This is how the histogram looked before the Levels adjustment.

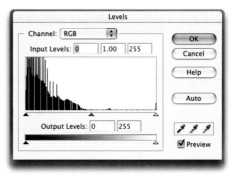

⇒ This is how it looked after the Levels adjustment, which involved moving the highlights triangle to just inside the right side of the mountain. (Moving the slider to just inside the right side of the mountain for any image should bring back the highlights.)

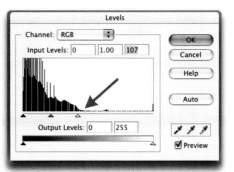

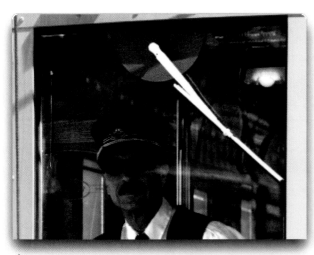
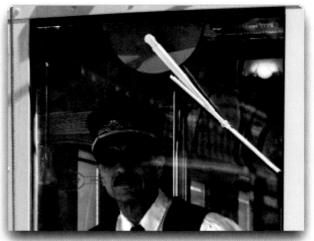

⇑ Here is why we had to make a duplicate layer. In this pair of screen shots, you can see that the windshield wiper is very washed out in the first image, a result of adjusting Levels to reveal the formerly hidden area inside of the trolley car. To reduce that annoying bright area of the picture, go to the Tool Bar, select the Eraser Tool, and erase the area over the windshield wiper. That will reveal the same area on the bottom layer that was unaffected by adjusting Levels.

⇘ Here is how the same image looks after adjusting Levels and with a bit of erasing.

The conductor is the main subject in this picture. To draw more attention to him, I decided to darken the window to his right, our left.

To do that, we'll use the same selection technique as we did for the conductor's window.

⇓ After making our selection, go to Levels. In this case, move the triangle on the shadow side of the slider to the point shown inside the mountain. (Doing that on any image will make the image darker.) After you click OK, the window to the side of the conductor is darker.

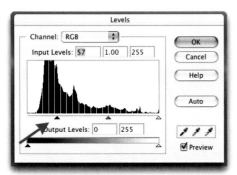

⇒ Here is the final image. It was definitely worth a few minutes' work in the digital darkroom.

But we are not done quite yet.

⇓ Go to the Menu Bar > Adjust Color > Hue/Saturation.

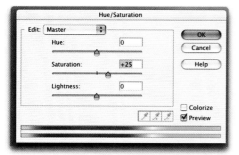

⇑ Now move the Saturation slider to the right to increase the saturation, creating the effect that the picture was taken in brighter sunlight and later in the afternoon.

⇒ Here's the result of an increase in saturation.

Sharpen

Turn Soft Shots into Crisp Shots

LEARN ABOUT
Sharpen
Unsharp Mask
nik Sharpener Pro!
Printing

In this lesson, we will learn about sharpening images by working with a picture from Big Cat Rescue, about an hour north of Tampa, Florida.

⇑ **Work Image #6A: Yawning Serval** Let's begin with a slightly soft picture of a serval cat.

⇒ The Sharpen tool on the Tool Bar is a quick, easy way to sharpen a section of an image. Simply click on the tool, select a brush size, and select a Strength. I usually start out somewhere below 50 percent. Move the brush over the areas you want sharpened.

⇒ Be careful about the Strength setting on the top Menu Bar. If you start sharpening at 100 percent, the effect will be applied too rapidly. You will quickly oversharpen,

getting a very pixelated section of your picture, as illustrated in this example.

⇓ To sharpen the entire image, you have three Filter choices in Elements, but pros only use Unsharp Mask, found by going to the Menu Bar > Filter > Sharpen > Unsharp Mask. Unsharp Mask is a term printers use to describe a sharpening process that is used during

the printing of books, magazines, posters, and so on. In Photoshop Elements, it gives you the most control over the sharpening process.

⇒ When using Unsharp Mask, keep the Radius and Threshold relatively low, and use the Amount slider to achieve the desired degree of sharpness. For accurate sharpening control, use the + and – buttons to fill the preview window with the most

important part of a picture. You can also click inside the preview window (a little hand appears) to move the image around.

⇓ Here's the effect of using the Unsharp Mask at 196 percent. Tip: A rule of thumb is that the larger the image file (file size), the higher the amount of Unsharp Mask that can be applied.

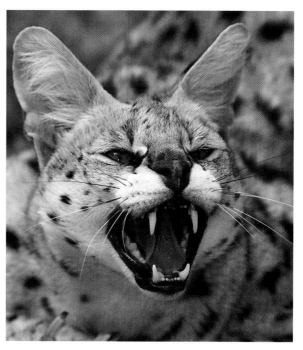

⇑ When using the Unsharp Mask, be careful not to oversharpen an image. If you do, you'll get a very noisy (grainy) image, as illustrated by this example.

Now let's take a look at a Photoshop-compatible Plug-in that makes sharpening a picture extremely easy. It's a Plug-in from nik multimedia called nik Sharpener Pro! You need to purchase this Plug-in separately. For information on nik Sharpener Pro!, see www.nikmultimedia.com.

⇒ **Work Image #6B: Cruiser Butterfly**
Here's a shot I took of a cruiser butterfly at Butterfly World in Coconut Creek, Florida. It's a bit soft.

⇒ After you install a Plug-in into Photoshop Elements (or any Photoshop Plug-in–compatible program), it appears at the bottom of the Filter menu. Here's a look at some of the options that nik Sharpener Pro! offers, which include sharpening for an inkjet print. I use this feature all the time for making prints on my desktop.

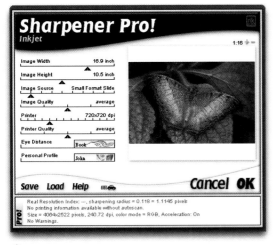

⇑ When you select the option you like from the nik Sharpener Pro! submenu, a dialog box opens that gives you control over the sharpening effect for particular applications. Controls typically include: Image Width, Image Height, Image Source, Image Quality, Printer, Printer Quality, Eye Distance, and Personal Profile; but controls vary based on what output option you choose. After you have made your adjustments, click OK and the sharpening effect is applied. As you can see, these settings are much easier to understand than Threshold and Radius in the Unsharp Mask dialog box.

⇑ Here is my final image, sharpened with Sharpener Pro!, with just a touch of help increasing contrast with Enhance > Adjust Brightness/Contrast > Brightness/Contrast.

Tip: Just increasing contrast can also make a picture look sharper.

⇛ If you want to make a print, you can control the print's sharpness in the printer menu. Be sure to set Print Quality to Fine (or Best or Highest) and use high-quality photo paper.

Have fun sharpening. But please remember: It all starts with the image, so strive for the sharpest original picture possible in your camera. Often, that means shooting at the lowest ISO setting (ISO 50 or 100) and setting the Image Quality at High/JPEG or, better yet, RAW.

Increase Light

Correcting Underexposed Image Areas

LEARN ABOUT
Dodging
Layers
Brightness/Contrast
Erasing

I have learned, through experience, to underexpose all my digital pictures slightly. In the digital darkroom, bringing back slightly dark images is easier than bringing back washed-out highlights. Sometimes, the latter is impossible. In this lesson we'll learn how to enhance the exposure of an image to make it match what we saw when we looked through the camera's viewfinder. These adjustments are often necessary because our eyes can see a wider contrast range than any digital image sensor. We'll also learn how to improve existing lighting conditions.

⇐ **Work Image #7A: Vietnamese Holy Man** Let's begin with a picture of a holy man in a temple in Vietnam. To avoid overexposing the man's robe, I intentionally underexposed my picture by 1/2 stop, which reduces the amount of light reaching the image sensor. That's why the picture is a bit dark.

⇒ Had I set the exposure for the man's face, the robe would have lost some of its detail.

⇓ Had I exposed for the man's robe, the face would have been too dark.

⇒ Now, you might think that just lightening the man's face with the Dodge Tool would be a good idea. It is effective, as you read in the Tool Bar section. However, simply dodging an area may make that area appear flat and unevenly exposed, as illustrated here. So, there is a better, more advanced way to lighten an area of a picture evenly—using Layers.

Here's the process we'll use on my picture of the holy man.

⇧ First, make a duplicate layer by opening the Layers palette (Menu Bar > Layers). Then, drag the Background Layer to the New Layer icon at the bottom of the palette. (Elements 3.0 users: Pull up to create a new layer.) Next, turn off the top layer ("Holy Man copy") by clicking on the eye icon image next to the image in the layers window.

⇩ The next step is to click on the bottom layer ("Holy Man") to activate that layer. That layer becomes highlighted.

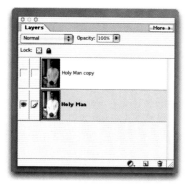

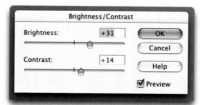

⇧ Now that the bottom layer is activated, go to Enhance > Brightness/Contrast and boost the Brightness and Contrast until you are pleased with the look of the man's face. Don't be concerned with the other areas of the picture. They will be "hidden" soon.

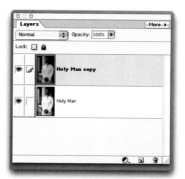

⇧ Now go back to your top layer. Next, select the Erase Tool from the Tool Bar and erase the area over the man's face. While you are at it, also erase the area over the man's hands, because they should be about the same brightness as the man's face.

⇩ To check your erasing, turn off the bottom layer by clicking on the eye icon next to the picture in the Layers palette.

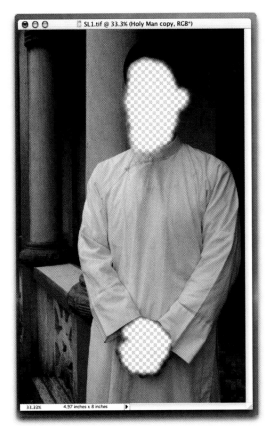

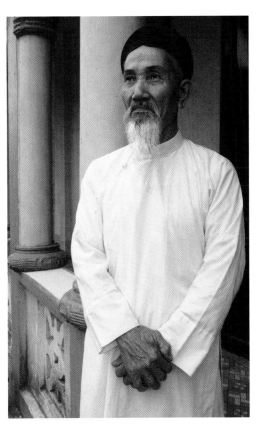

⇑ With the bottom layer turned off, this is how the picture on your monitor will look.

⇑ The beauty of having different areas of a picture on different layers is that you can adjust each layer individually. After I was all done fixing the light on the man's face, I went back to the top layer to lighten it just a bit.

⇑ Okay, all you keen-eyed photographers. I know you noticed that the man's eyes are brighter in my fixed picture. That's because I used the Dodge Tool to lighten the whites of the man's eyes, which draws more attention to them. These screen shots show the before-and-

after effect of dodging the man's eyes. For more on this technique, see "Workshop #9: The Eyes Have It."

Here's another example of the effectiveness of adjusting the Brightness and Contrast on a separate Layer.

⇊ Work Image #7B: Butterfly Orchid

I photographed this butterfly orchid at the Bronx Botanical Gardens. As you can see, the background looks dark, too dark for me. With Elements, we can bring back some of the details in shadow areas quite easily.

⇊ I first tried boosting the Brightness and Contrast of the entire image.

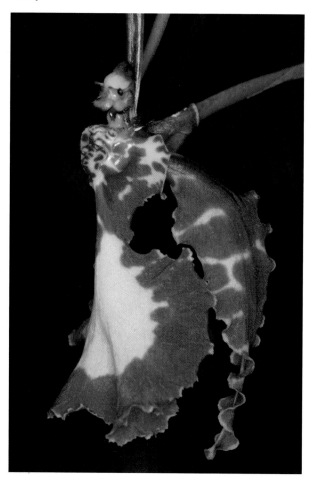

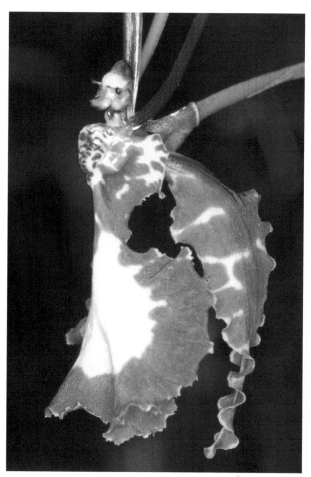

⇑ As you can see in this image, boosting the Brightness and Contrast resulted in some green and brighter areas in the background, but the beautiful flower is now washed out.

Here is a better way to fix the light.

⇒ Follow the above instruction for making a duplicate layer. Next, go to the bottom layer and boost the Brightness and Contrast, as I originally did on this image. Then, go to the top layer and selectively erase the area around the flower. That will let the improved background area show through without affecting the flower area of the top (unadjusted) layer.

⇐ Here's the result of the more advanced exposure-correcting technique.

Create New Light

Add Lighting to an Image

Sometimes, a picture would be improved by creating new light within it. In Elements, we can add light to an image with a particular direction, quality, or intensity. That's pretty amazing, in my book.

⇐ **Work Image #8A: Young Woman** We'll begin by using a portrait of one of my friends, Chandler. Taken on an overcast day, the photograph contains light that is diffused and soft. I like the lighting, but let's see what creative options Elements offers.

⇐ On the Menu Bar, we create light at Filter > Render > Lighting Effects.

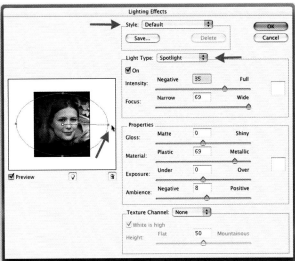

⇑ When we select Lighting Effects, the dialog box opens at the Default setting for the style of lighting we want to create. More than a dozen different choices of lighting style are available, each with light that originates from different orientation or from one or more sources. As you become familiar with this tool, you will want to play around with lighting styles beyond Default.

⇑ We'll start by choosing the Default style setting and the Spotlight as the Light Type. In the Preview window we click on the anchor point (the little white circle in the center of the newly lit area) and move the oval around until it creates the lighting effect we like, as illustrated in this screen shot.

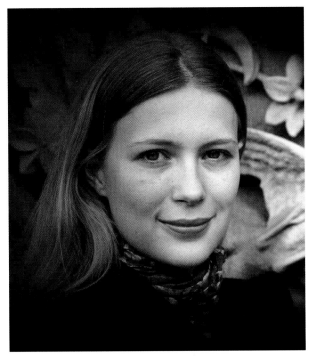

⇐ After we click OK, Chandler's portrait should look like this, with nice side lighting.

⇓ To experiment, select Omni as the Light Type and adjust the Intensity and Ambience sliders as shown in this screen shot.

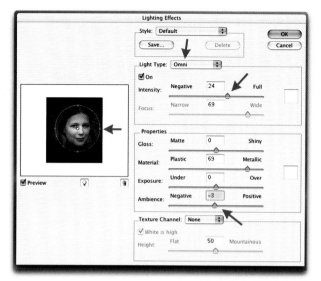

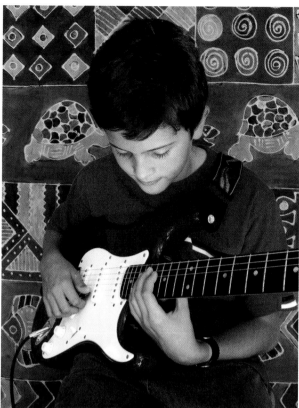

⇑ **Work Image #8B: Young Guitarist** Now let's work on the picture of the young guitar player.

⇓ Select Flashlight as the Style and leave Omni as the Light Type.

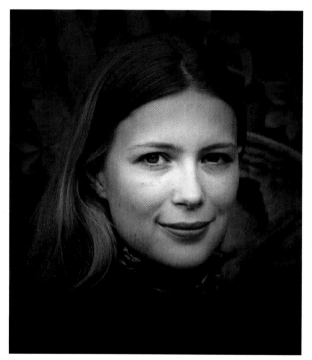

⇑ After we click OK, Chandler's portrait has a center spot.

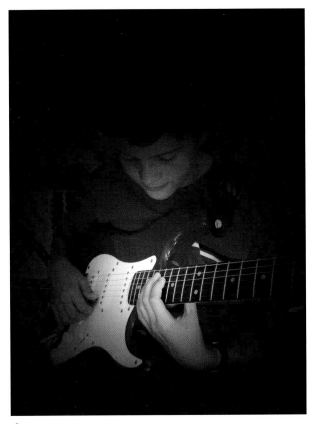

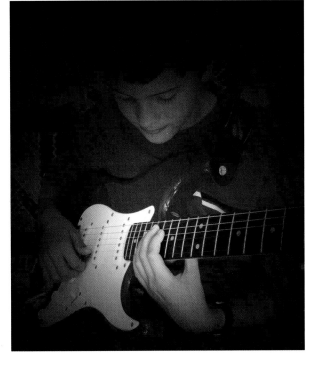

⇑ After we click OK, the guitarist's portrait should look like this, perhaps recalling the type of lighting we might see in a nightclub.

⇒ I like to fill the frame with the main subject. To add a bit more impact to the picture, I cropped the image a bit to remove some of the dead space encircling the guitarist.

Play around with lighting effects. The results are virtually unlimited.

The Eyes Have It

Concentrate on the Eyes for Great Portraits

LEARN ABOUT
Red Eye Brush Tool
Dodge Tool
Clone Stamp Tool
Add to Selection
Elliptical Marquee Tool
Levels
Blur Tool

When it comes to portraits of people and animals, the eyes are of the utmost importance. In this lesson we'll take a look at several different ways to enhance a subject's eyes and to draw more attention to them.

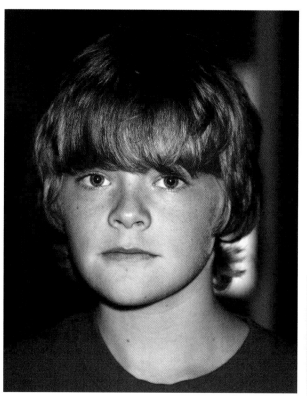

⇐ **Work Image #9A: Blond Boy** Here's a picture of one of my son's friends, Adrian. As you can see, he has a bad case of "red eye." Use the Magnify Tool to enlarge the view of your subject's eyes.

⇒ Elements makes it easy to fix red eye. First, select the Red Eye Brush Tool from the Tool Bar. Then, move your brush into the image area. Use the [key to make your brush smaller, or use the] key to make the brush larger. Place the brush over the red part of the subject's eyes and click until the all the red is removed.

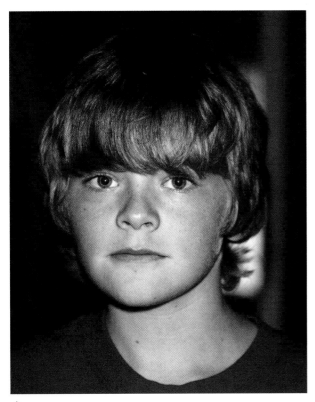

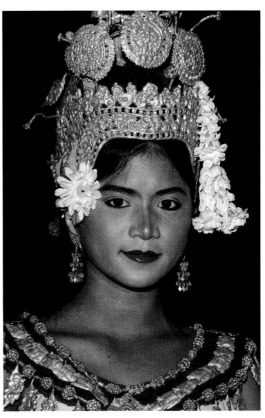

⇑ With just a few clicks, the red eye is totally removed.

Here's a trick art directors and photographers use to draw more attention to a subject's eyes, using the following easy steps.

↗ **Work Image #9B: Cambodian Dancer**
I like the lighting on the face of this dancer in Cambodia, and the intensity of her eyes.

⇐ Select the Dodge Tool from the Tool Bar, choose a small brush size, and brush over only the whites of her eyes.

⇒ Compare this picture with the original. The dancer's whiter eyes make us immediately make eye contact with her.

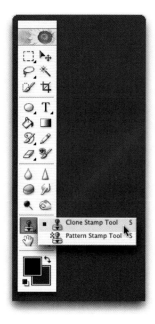

⇒ **Work Image #9C:
Iguana** In the eye of this
green iguana, we can see
the reflection of the two
tubes of the ringlight I
used to photograph the
animal.

⇐ To remove those unnatural-looking reflections, we can use the Clone Stamp
Tool on the Tool Bar. Magnify the eye area.

After selecting the Clone Stamp Tool and a small brush size, simply move the
brush onto a black area of the eye (after using the Magnifying Tool to enlarge the
image so you can easily work on a small area), click while holding down the Option
(Mac) or Alt key (PC), which picks up that black area, and then move your brush
over the annoying areas (which pastes the black area over the white area).

⇓ Presto! The reflection of the ring light is removed.

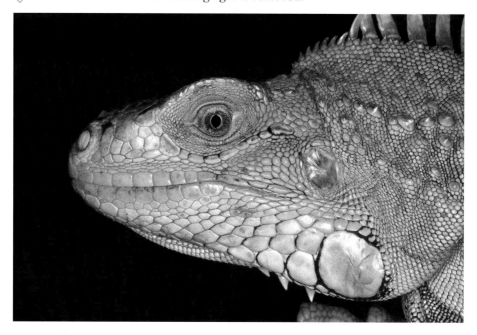

⟫ Work Image #9D: Young Cougar

Here's a technique for brightening the entire eye area. We'll use a picture of a cougar I took at Big Cat Rescue in Tampa, Florida.

⤋ First, click on the Add to Selection icon in the Menu Bar.

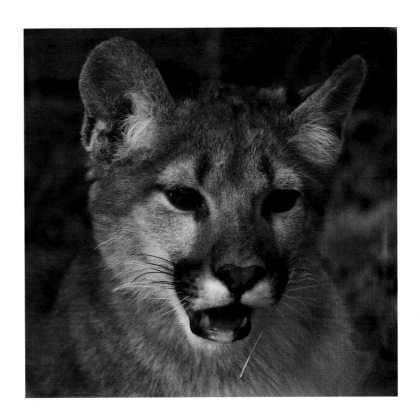

⟸ Next, select the Elliptical Marquee Tool. Then, click inside the image to activate the Elliptical Marquee Tool.

⟹ Next, start to select the animal's eyes. Because we have clicked Add to Selection, we can keep selecting areas of the animal's eye until the entire eye area is selected. We need to do this because the animal's eye cannot be perfectly selected with just one selection.

⟹ Once both eyes are selected, go to the Menu Bar > Adjust Brightness/ Contrast > Levels.

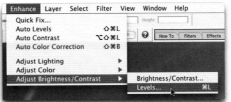

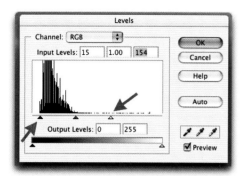

⟸ Next, move the sliders as shown. When you are pleased with the new look (Levels) of the animal's eyes, click OK.

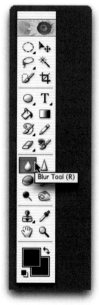

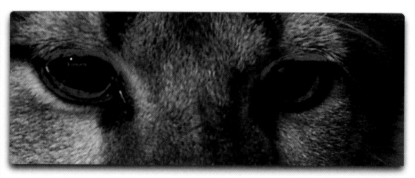

⟸ ⇑ If the eyes look unnatural—that is, too bright compared to the rest of the animal's face—select the Blur Tool from the Tool Bar and, choosing a small brush, go over the areas around the subject's eyes, as shown by the shaded areas in red that I have added. That will make the transition from the adjusted Levels areas of the eyes to the non-adjusted areas of the animal's face more gradual and more natural looking.

⇒ Compare this image with the original. As you can see, the eyes have it!

Intensify Landscapes

Transform Your Outdoor Images

The late Ansel Adams was among the first to admit that darkroom work played a very important role in his work. In the digital darkroom, we have even more control over the images that we capture with our camera, especially when you consider all the digital filters that can be applied to a picture.

⇓ **Work Image #10: Mexican Hat, Utah** In this lesson we'll use some of the features in Photoshop Elements to transform a dull landscape picture I took in Utah. "Why use a lackluster picture?" you may ask. Ansel Adams's most famous print, *Moonrise Over Hernandez*, started out as a very dull print. I have friends who have seen it. As a master of darkroom technique, he was able to transform the flat, low-key negative into a masterpiece by experimenting with different exposures, papers, and chemical mixtures, and by selectively burning (darkening) and dodging (lightening) parts of a picture.

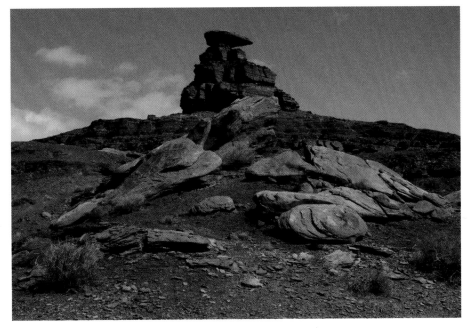

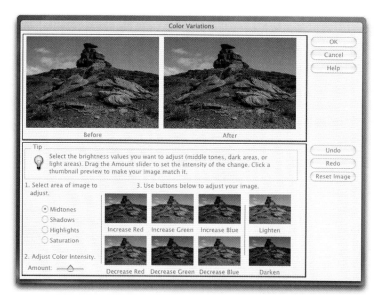

For a quick and easy look at how a scene can be enhanced, check out Color Variations. You get there by going to Enhance > Adjust Color > Color Variations. After the Color Variations dialog box opens, you click on the different pictures to see how changes in brightness and color balance will affect a picture.

In this case, I clicked on Darken, because the picture looks too light to me. Play around with Color Variations. You may come up with a surprisingly improved picture. Keep in mind, however, that Color Variations is not the best way to enhance a picture. Following is the best way, as shown by example.

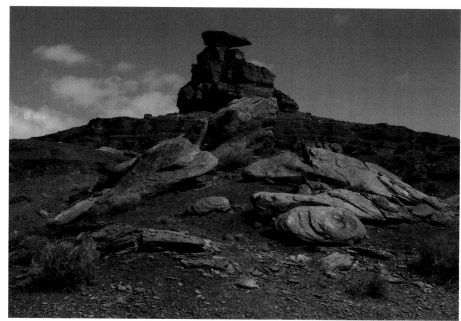

Go to Levels (Enhance > Adjust Brightness/Contrast > Levels).

When you choose Levels, the Levels dialog box will open. This is where you have a tremendous amount of control over your image. As shown by the histogram, the image lacks a lot of shadow (right side of histogram) and a bit of highlight (left side of histogram) detail (see my red arrows).

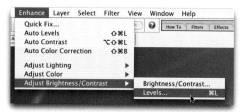

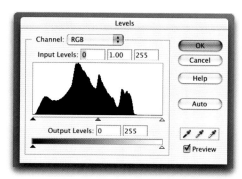

⇒ Here I adjusted the Levels by moving the slider arrows inside the mountain in the Levels histogram, which is the basic technique for enhancing the shadow and highlight levels in a picture. Experiment with different slider positions to see how they affect the image.

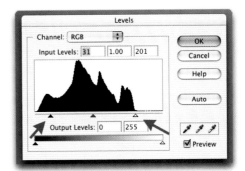

⇘ Here is the effect of correcting the Levels. As you can see, the result is much more dramatic—and pleasing—than simply choosing Variations.

Let's continue working with this image. But before we do, let's see how just a bit of cropping can enhance it.

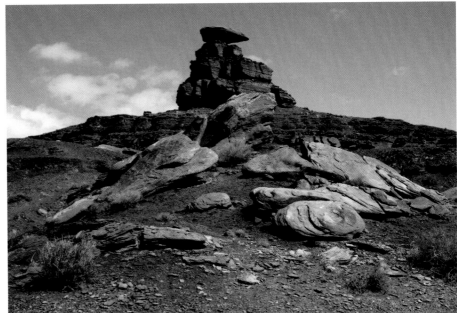

⇘ Cropping just a bit off the right and left side of the image and a part of the bottom of the image gives the image a bit of more impact.

I took the picture around midday, when the light was "cool," meaning that the image has a slight blue cast. I wanted to photograph Mexican Hat in the late afternoon, but I was on the move and had to get to another location. So, I created late afternoon lighting, a "warmer" quality of light with deeper shades of red and yellow, in Elements. Here's how to do it.

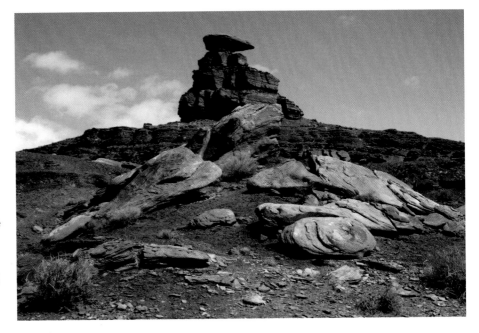

⇩ Go to Enhance > Adjust Color > Hue/Saturation.

⇩ In the Hue/Saturation dialog box, choose Edit: Yellows and boost the Saturation. Here I boosted it to +38. Click OK.

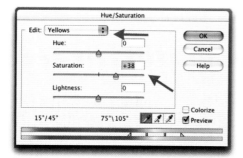

⇩ Now go to Enhance > Adjust Color > Hue/Saturation, and when the dialog box opens, choose Edit: Reds. Here I boosted the Reds to +25.

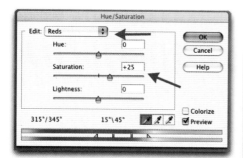

We are not done yet!

Landscape photographers who work in the wet darkroom and the digital darkroom often darken the edges of a picture to draw more attention to the main subject in the center of the frame. That's easy to do in Photoshop Elements.

⇩ First, select the Rectangular Marquee Tool in the Tool Bar. Then click in the picture and select an area about an inch or so into the frame. A dotted white line shows the selected area—inside the line.

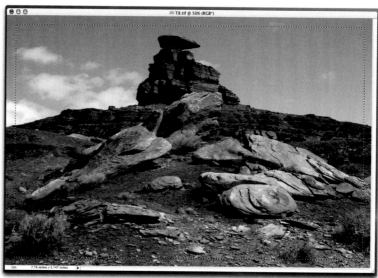

⇒ Next go to the Menu Bar and choose Select > Inverse.

⇩ Now the area outside of your dotted white line is selected, shown by the original dotted line and a dotted line around the border of the picture.

⇒ For a smooth transition to what you are about to do (darken the edges in the inversely selected area), go to the Menu Bar, choose Feather, and select a Feather of 200.

⇒ Now it is time to darken the picture. Go to Enhance > Adjust Brightness/Contrast > Levels and move the Shadow triangle on the slider bar to the right to darken the edges of the picture.

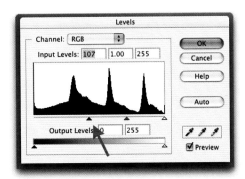

⇒ After you click OK, the edges of the picture are evenly darkened.

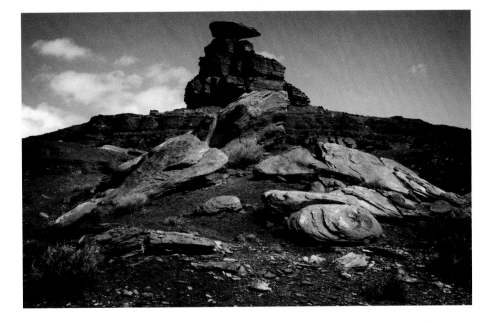

⇒ We did a lot of work in this lesson. To make it easy for you to see just how much work, here is a before-and-after screen shot of the image. Guess what? We are still not done yet! In honor of all those black-and-white photographers out there, let's convert this image to a black-and-white image.

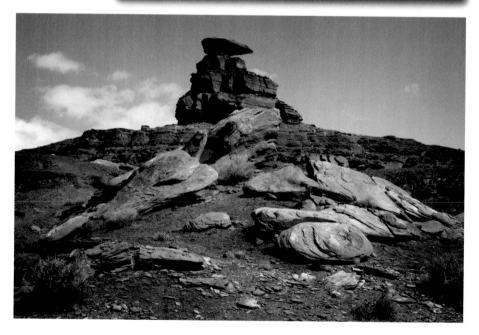

⇓ Go to the Menu Bar and then to Enhance > Adjust Color > Remove Color.

⇒ Here's how the image looks when we remove the color.

⇑ You can make subtle (or dramatic) enhancements to the image using Levels, as I did here for a very subtle enhancement of making the whites whiter.

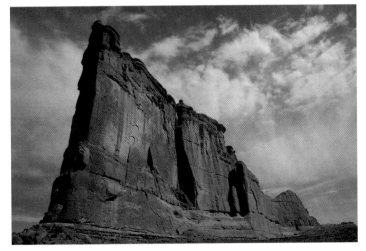

⇒ Some of the adjustments in my Mexican Hat photo were subtle. In this before-and-after set of images, taken at Arches National Park in Utah, I used the above techniques for a dramatic result.

Create Black and White from Color

And Try Your Hand at Infrared Images

LEARN ABOUT
Remove Color
Hue/Saturation
Auto Levels
Burn Tool
Layers
Diffuse Glow

Would you like to give your color digital files a new life in black and white? Or, how about converting them to infrared images in the digital darkroom? We can do that quite easily with Photoshop Elements.

As an illustration, we'll use a portrait photograph from a trip I made to the temples of Angkor Wat, Cambodia.

⇩ **Work Image #11: Angkor Wat** Here's the original color scene, captured with my Canon EOS 1Ds, set to the RAW mode for maximum detail and color control.

⇒ A fast way to create a black-and-white image is to convert the color image to a grayscale (black-and-white) image. Open the image and then go to Enhance > Adjust Color > Remove Color.

⇒ I'm sure you'd agree that the picture looks too dark and flat. It lacks contrast among its copious midtones. (If you ever move up to Photoshop CS, the best way to get a good black-and-white image is by using Channel Mixer, which I discuss in my *Complete Guide to Digital Photography.*)

⇓ There is another way to convert a color image to black and white. Go to the Menu Bar and then to Enhance > Adjust Color > Hue/Saturation, and then move the Saturation slider all the way to the left.

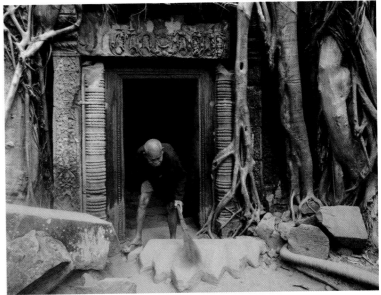

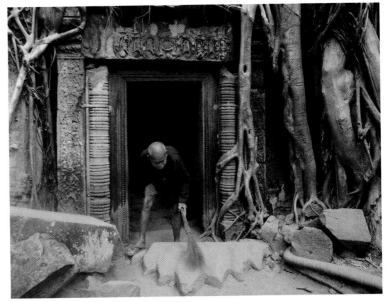

⇑ Here's the result of desaturating the image. I can't see any difference in the Hue/Saturation method and the Remove Color method.

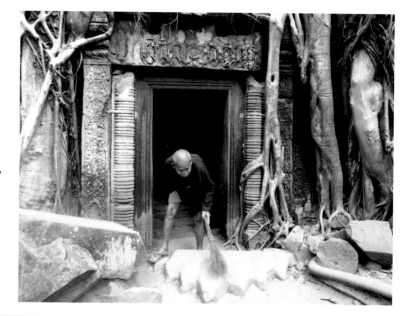

⇒ Here's my black-and-white image, but with Auto Levels (Enhance > Auto Levels) applied. Auto Levels automatically (and magically) "rescues" the highlight and shadow areas of this picture.

⇑ To create a black-and-white image, we can also use the B/W Conversion filter in a Plug-in called nik Color Efex Pro 2.0, from nik multimedia. (This Plug-in is sold separately. See www.nikmultimedia.com for information.) Working in Basic Mode with this Plug-in, we have total control over Brightness, Contrast, and Spectrum.

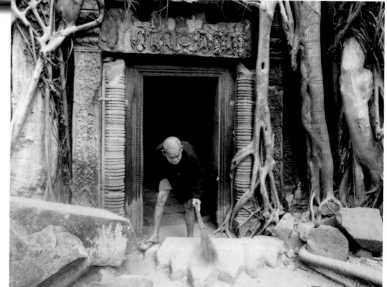

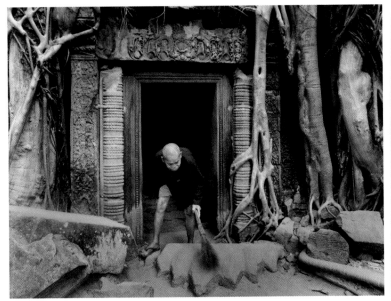

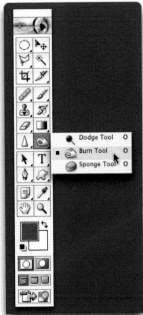

⇑ In this version, I darkened the edges using the Elements Burn Tool (see the Tool Bar section), to focus the viewer's attention more on the man. Renaissance painters, and well-known photographers such as Ansel Adams, darkened the edges of their pictures to draw more attention to the main subject in a scene. Play around with the Burn Tool on this image to see how you can draw more attention to the man, the main subject in the scene.

With Photoshop Elements, it's easy to create a black-and-white infrared image because you can "fade" the Diffuse Glow Filter (Menu Bar > Filter > Distort > Diffuse Glow), which, when applied to a black-and-white image like this one and faded, creates an infrared effect. Here's the trick to "fading" the filter, a feature that is automatically built into Photoshop CS but is not automatically built into Elements.

⇓ Create a duplicate layer by dragging your original layer (down in Elements 2.0 and up in Elements 3.0) to the Create a New Layer icon.

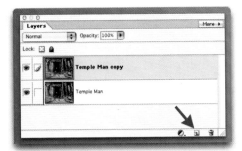

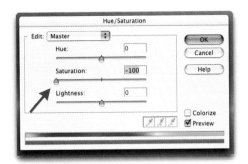

⇑ Next, on both layers (click on a layer to activate it), desaturate the image by going to the Menu Bar and then to Enhance > Adjust Color > Hue/Saturation, and then move the Saturation slider all the way to the left.

⇒ Now apply the Diffuse Glow (Filter > Distort > Diffuse Glow) Filter to the top layer.

⇓ Elements may have a different idea of the infrared effect than you or I do. Here the default setting produced an image that I feel is too washed-out. The image is cropped to fit on this page.

⇒ To reduce the washed-out effect, reduce the Opacity on the top layer in the Layers palette until you are pleased with the result.

⇓ Here's the result of my fading the Opacity. I think it's pretty close to an infrared effect. You need to play around with the Opacity, as well as the intensity of the Diffuse Glow Filter, to get the precise effect you want.

Other options for enhancing black-and-white images are to use Brightness/Contrast (Menu Bar > Enhance > Adjust Brightness/Contrast > Brightness/Contrast) and Levels (Menu Bar > Enhance > Adjust Brightness/Contrast > Levels).

With Photoshop Elements, the creative black-and-white options available are unlimited—especially when you add your own sense of creativity. Try these options for tweaking your images to suit your personal preferences.

Add Color to Black and White

Add Sepia to an Image

LEARN ABOUT
New Layer
Layer Mode
Color Layer
Swatches
Brush Tool
Brush Opacity

One of my earliest photographic memories is seeing a black-and-white picture that my mother colored by hand with a brush and colored inks. It was magical to see the transformation from a black-and-white picture that my dad had taken to a color picture that my mother painted. In the digital darkroom, hand-coloring a picture is easy and full of possibilities. Let's take a look at a few coloring techniques.

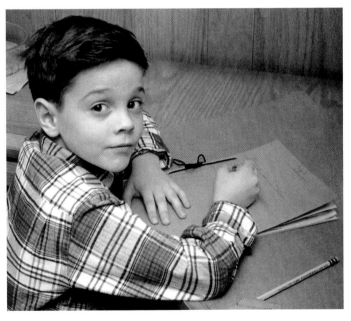

⇐ **Work Image #12: Boy at Desk** We'll use a black-and-white picture that my dad took of me when I was a child.

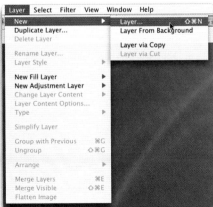

⇐ First, we need to create a new layer. On the Menu Bar, go to Layer > New Layer.

⇒ Next, we need to select the Layer Mode in the Layers palette; in this case, we want to choose Color, because we only want to color (hand-color/paint) on this new layer.

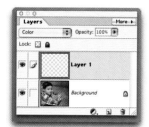

⇐ When we look at our Layers window, we now see our original layer below our new layer (the layer we'll paint on), which is blank.

⇓ On the Menu Bar's Palette Dock, click the Swatches palette to reveal the different colors in Swatches. (You could also access the Color Picker at the bottom of the Tool Bar, but

let's work with Swatches.) Because we want to start the process by coloring my face, click on Pale Warm Brown. You will see these color names in the Swatches palette when you drag your mouse across each color patch.

⇓ To begin coloring, click on the Brush Tool in the Tool Bar and select a soft airbrush. You can change the size of the brush by using the bracket keys on your keyboard:] makes the brush larger, [makes the brush smaller.

Now, simply move the brush over that area of the image you want to color. Start with the Brush Opacity (on the Menu Bar) set to about 50 percent. That setting lets you apply color at a slower rate than if your brush was set to 100 percent. When hand-coloring any picture, it's best to use a slowish application, for maximum control.

For each new color with which to paint, go back to Swatches to select the next color.

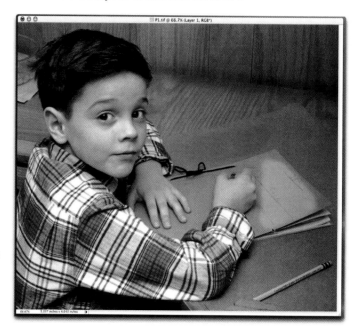

⇒ This screen shot shows the effect of selecting different colors and painting different areas of the picture.

During the hand-painting process, it's a good idea occasionally to turn off the bottom layer (click on the eye icon next to the picture in the Layers window) to check to see if you have missed any areas of a picture.

Try not to paint over the same area twice. If you do, that area becomes darker than areas you only paint over once. You'll notice the darker areas mostly on a subject's face or in other plain areas of a picture.

If you do get streaks on a plain area, use the Dodge Tool in the Tool Bar to lighten that area.

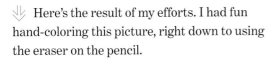 Here's the result of my efforts. I had fun hand-coloring this picture, right down to using the eraser on the pencil.

Add Motion to Still Subjects

Simulate a Slow Shutter Speed

LEARN ABOUT
Motion Blur
Layers
Erasing
Radial Blur

Slow shutter speeds create a sense of action and motion in a still photograph. Photoshop Elements can simulate the blurred motion we see with a slow shutter with more creative control and predictability, because we can fine-tune the motion effect as we move along in the image editing process.

⇑ We add Motion using the Photoshop Elements Motion Blur Filter, which is listed under Blur in the Filter menu. As you can see, there are several Blur choices. We'll look at Motion Blur and Radial Blur in this lesson.

⇐ **Work Image #13A: Jaguar** We'll begin with a picture I took of a jaguar at the Belize Zoo.

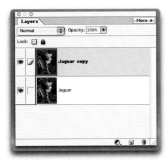

⇐ For this picture, and the other pictures in this lesson, we'll apply the filter only to the top layer of a two-layer file and selectively erase the blur to produce the desired effect. Along the way, you'll see why Layers are essential for this Photoshop Elements magic trick.

So, the very first step when working on each image is to create a two-layer file. Do that by opening the Layers Dialog Box (Menu > Window > Layers) and then by dragging the Background Layer to the Create New Layer icon in the Layers palette.

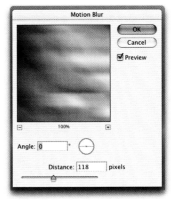

⇒ After you select Motion Blur from the Filter menu, the Motion Blur dialog box opens. In that dialog box, we have control over the Angle of Blur and the Distance in pixels. Because we want to create the effect that the jaguar was quickly turning its head, set the Angle at 0° and the Distance at 118 pixels. You need to play around with these settings to get the precise effect that you will like best.

⇓ Here's the effect of the entire top layer's being blurred.

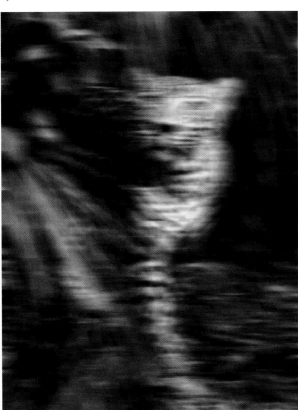

⇓ The next step was to erase most of the top layer, because we only want the animal's head blurred. Here's how the top layer looks when we turn off the bottom layer (by clicking on the eye icon).

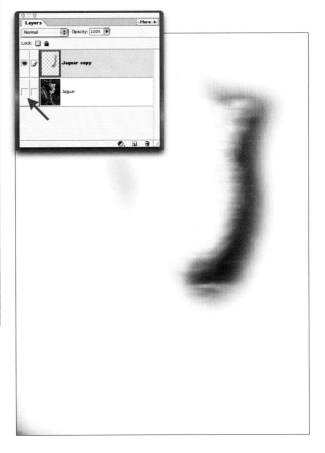

⇊ With both layers turned on, this is how the image looks, with just a touch of blur.

So, again, the key is to use Layers, apply the Blur filter to the top layer, and then erase selectively.

Here is another example of how we can add a sense of motion to a picture—using a different blur filter applied to the top layer. Again, you need to create a two-layer file as your first step.

⇒ Here's an important tip for erasing: As you move outward from the main subject, reduce the Opacity of your brush in the Menu Bar. That will smooth the transition between blurred and sharp areas of your picture.

⇑ **Work Image #13B: Grey Pansy Butterfly** Now let's go for a spin, applying the Spin Blur Filter in the Radial Blur dialog box one of my Grey Pansy Butterfly photographs.

⇐ In the Radial Blur window, we can control the amount of Spin. I chose 16 pixels for a subtle effect. As always, experiment with Amount to get precisely the effect you want.

⇊ Here's how the Spin Radial Blur Filter affected my picture, after it was applied to my top layer and I erased most of the area of the butterfly's body on that top layer.

Your turn! Enjoy adding a sense of motion to your still pictures.

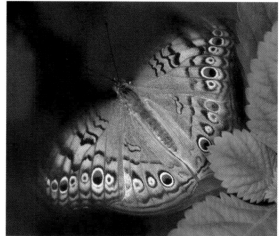

Filters

Create Sophisticated Effects

Before I became involved with digital image enhancing and editing, I did not consider myself an artist. I took pictures on negative or slide film, had them published, and was relatively happy with my work. However, I always thought about being more creative with my images after they came back from the developer. The digital darkroom in our computer can awaken the artist within each of us.

This lesson offers some examples of how the filters in Photoshop Elements can turn a straight shot into a more artistic and creative image. To illustrate just some of the creative doors that digital filters can open, I've applied a few of my favorite filters to the same picture.

Take a look. Then have some fun tweaking a filter's effect or even applying different filters to my image.

Keep in mind that as the amount of RAM (Random Access Memory) in your computer increases, the time it takes to apply a filter to an image decreases. So, install as much RAM as you can afford if you plan to use filters on your images.

⇓ **Work Image #14: Horses** In this lesson we'll use a picture I took of some horses running directly toward me at the Double JJ Ranch in Rothbury, Michigan.

All of the Elements filters can be accessed in two ways, after opening an image.

← One, by going to the Menu Bar, clicking on Filter, and scrolling down to select the individual filter.

⇒ Two, by clicking on the Filter Tab on the Menu Bar's Palette Dock and scrolling down to the individual filter. This second method gives a before-and-after example of each filter, and perhaps makes it easier to understand a filter's effect for novice users of Elements.

Okay, let's have some fun with filters.

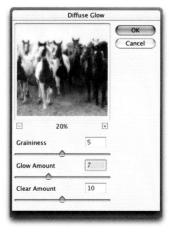

Diffuse Glow (Filter > Distort > Diffused Glow). Experiment with the Graininess, Glow Amount, and Clear Amount sliders to produce unlimited creative effects.

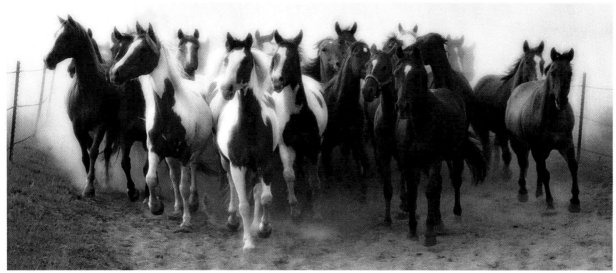

Diffuse Glow Filter converted to black and white.
Go to Enhance > Adjust Color > Remove Color.

⇓ Try converting your favorite color pictures to black and white for an alternative creative effect.

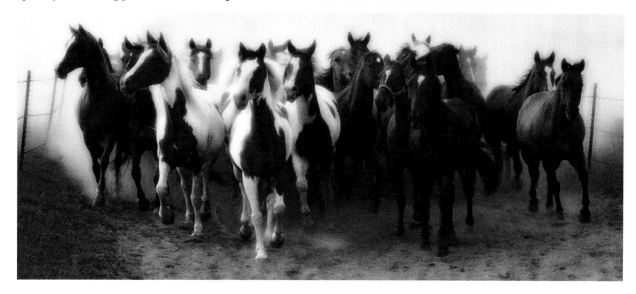

Add Noise. Go to Filter > Noise > Add Noise. In digital photography, grain is referred to as noise. You can easily add noise to an image using this filter. Here, too, play around with the sliders until you get the effect you like.

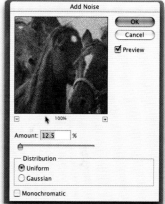

⇓ Here is the result of adding Noise to the picture.

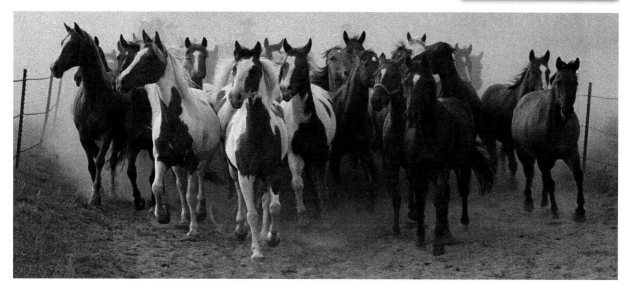

Chalk & Charcoal. Go to Filter > Sketch > Chalk & Charcoal. Tinker with the sliders until you have created your own "sketch."

 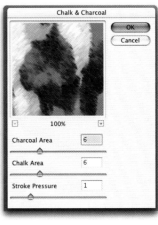

⇓ The Chalk & Charcoal Filter transformed a photograph into an image that looks more like a sketch.

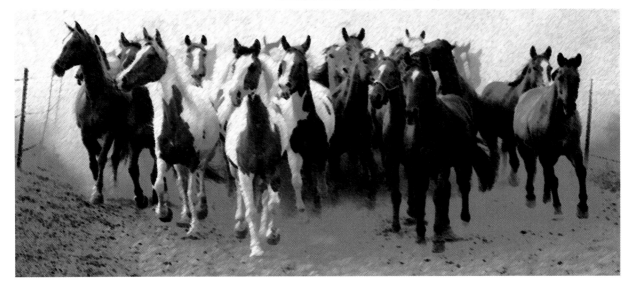

Fade a Filter. In Photoshop CS, we can easily fade a filter for even more creative effects. Fade Filter is not available in Elements, but we can achieve the same effect by using Layers. Here's how to do it.

⇐ Create a duplicate layer by dragging the layer in the Layers palette to the Create New Layer icon.

⇒ Next, apply the filter (the Graphic Pen, in this case) to the top layer.

 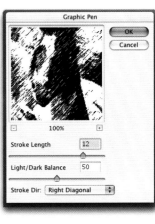

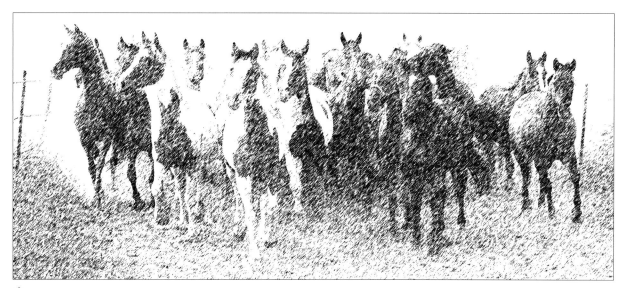

⇧ Here's the result of applying the filter. In this example, I don't like the effect, which is why we want to fade the filter.

⇐ Now, reduce the Opacity (see my red arrow) to reveal the unfiltered layer below, which fades the effect.

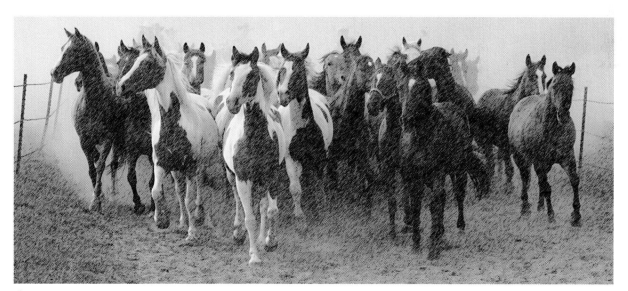

⇧ Here's the result of fading the Opacity by 30 percent. Experiment with fading the Opacity until you have achieved the desired effect.

Effects

Apply Instant Special Effects

Photoshop CS—the "big brother" to Elements—has an Actions feature under Window > Actions. This feature applies multiple effects to an image to create an overall special effect at the click of a mouse.

⇓ In Photoshop Elements, a scaled-down set of Actions is presented as Effects. To see the options presented in the Effects palette, click on the Effects tab in the

Palette Dock to view the available list. For easy access during this lesson, drag the Effects tab down off the Palette Dock. That will place it as an open window on your work area. You can put it back by dragging it back to the Palette Dock or by going to the Menu Bar > Window > Reset Palette Locations. (You can move all the tabs on the Palette Dock in the same manner.)

⇑ **Work Image #15: Palm Tree** We'll begin our Effects fun by using a picture I took of a palm tree in Kuna Yala, Panama.

⇑ **Colorful Center.** Select this Effect and the center of your image retains color while the other areas are converted to black and white.

⇑ **Drop Shadow.** This Effect requires you first to drag the image onto a slightly larger blank document. After your drag and drop, apply a Drop Shadow Effect.

⇑ **Photo Corners.** Try this Effect to simulate a photograph placed in a traditional photo album.

⇑ **Recessed Frame.** This Effect requires you first to select an area (use the Rectangular Marquee Tool).

⇑ **Soft Flat Color.** Try this Effect for a soft, pastel look.

⇑ **Vignette Selection.** Here, too, we first have to select an area of the frame to be vignetted. This time, try the Elliptical Marquee Tool.

⇑ **Wood Frame.** This Effect dresses up a picture with a natural-looking wood frame.

While you have the Effects palette open, experiment with the other Effects on my palm tree picture, and on your pictures.

Makeovers

Try Some Quick Touch-ups

In this lesson we'll learn about three techniques that fashion and portrait photographers use for their clients.

⤒ **Work Image #16A: Redheaded Girl** Let's begin with a technique for removing freckles. In this case, we'll use a picture of a beautiful girl with cute freckles. The technique for removing the freckles is the same one we'd use for removing any other skin irregularities, such as age spots or severe acne. To remove an individual mark on a person's face, use the Clone Stamp Tool as described in the workshop on that tool.

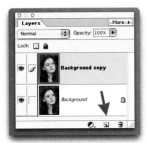

⇚ After opening a picture, make a duplicate layer in the Layers palette by dragging down your background layer to the Create New Layer icon at the bottom of the palette.

⇉ Next, we want to create a new blank layer. That's easy. Hold down the Command key (Mac) or the Control key (PC) and click on the Create New Layer icon. You'll now see a new, blank layer in the Layers dialog box in the middle of the two image layers.

⇉ Next, make sure the top layer, the new "background copy," is highlighted. If it's not, click on it. Then go to Filter > Blur > Gaussian Blur. Once the Gaussian Blur panel opens, you want to move the Radius slider to the right until the facial marks disappear.

⇉ Next, select the top blurred layer. To group the top two layers, press Command and G on a Macintosh or Control and G on a Windows computer.

⇊ In this screen shot we can see the Gaussian Blur effect. Don't worry that the entire image is blurred.

⇚ Now click on the new middle layer if it's not highlighted. Select the Brush Tool from the Tool Bar and use the bracket keys on your keyboard to make an appropriate brush size: [for smaller,] for larger. Now set the brush's Opacity on the Menu Bar to about 50 percent. Make sure your foreground color is on the default settings, with black in the foreground (because you want to paint with 100 percent black). If it's not, press D on your keyboard. Begin "painting" over the areas you wish to change—the freckles, in this case.

⇑ This screen shot shows the area over which I have painted.

⇑ The "mask" view and screen shot are made possible by turning off the bottom layer in the Layers palette.

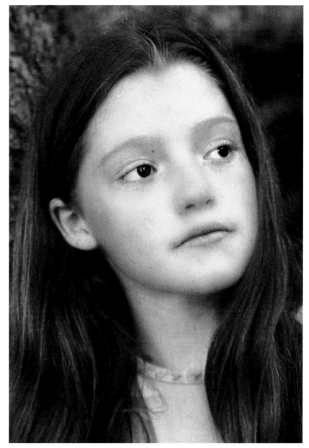

⇑ Here's my finished retouched photo, one in which the girl looks even more angelic.

Now we are going to learn about the Elements weight-reducing program. For this effect, we'll use the Liquify Filter.

⇓ Work Image #16B: Woman with Sunglasses

We'll use this picture of my friend Kristin on a beautiful fall afternoon. Professional retouchers use this technique on fashion photography, and Kristin was very good-natured about letting me demonstrate on her photo.

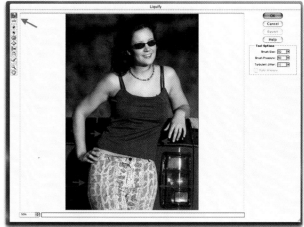

⇑ When we choose Filter > Distort > Liquify, a window opens. The Warp Tool we want to use is already selected (see the green arrow in the window's upper-left corner). Now simply move the brush over the areas you want to work on. Click and gently move the brush inward on the subject's body. My red arrows indicated the area on which I worked.

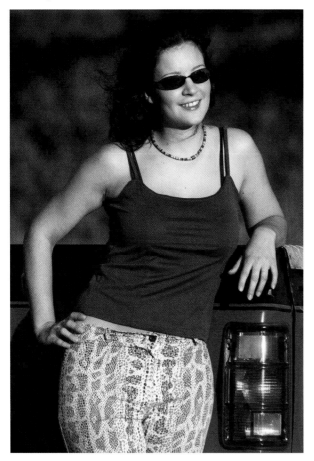

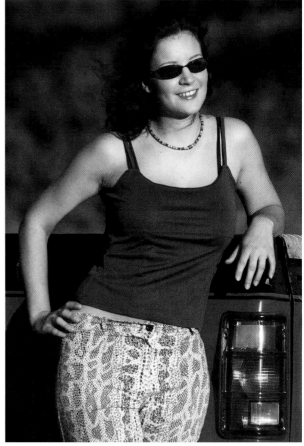

⇒ Here's the effect of using the Liquify Filter selectively on the arms and waist.

Here's a quick tip for transforming a straight shot into a glamour shot, the kind you may have seen in fashion magazines.

⇓ **Work Image #16C: Studio Headshot** Open a picture—in this case, the studio shot of the model.

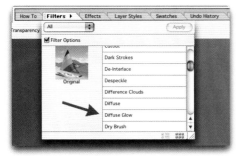

⇑ Go to Filter on the Menu Bar and select Diffuse Glow.

⇒ Selecting the Diffuse Glow Filter reveals this dialog box. Play around with the sliders until you are pleased with the effect.

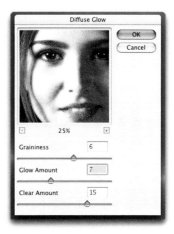

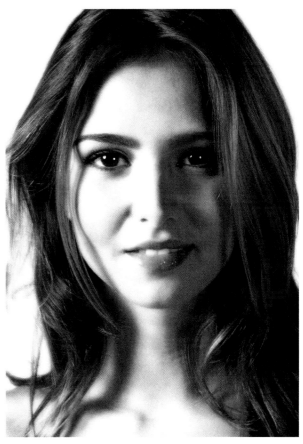

⇑ Click OK. Here's the result of my playing around.

We can have more fun with our fashion technique.

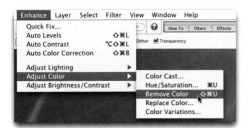

⇑ Go to the Menu Bar and then to Enhance > Adjust Color > Remove Color.

⇒ Here's a look at our model after we added the Diffuse Glow Filter and then removed the color.

Transform Perspective

Control and Alter Perspective in an Image

We often need a wide-angle lens to photograph a building at close range. Yet a wide-angle lens makes the building look as though it is falling over. To correct that, we could use what's called a perspective control (PC) lens, which costs about $1,500. This lesson could save you from buying such an expensive and specialized lens. In Photoshop Elements, we can correct that "falling over backward" problem to some degree.

⇑ **Work Image #17A: Supreme Court Building** Let's begin with a picture I took of the Supreme Court building in Washington, D.C. As you can see, the building looks as though it is falling over backward.

⇒ The first step is to select the Magnifying Tool in the Tool Bar. Then click inside the image area and,

holding down the Option key (Mac) or Alt key (Windows), click inside the image. This will reduce the size of the image on your screen, surrounding it with a gray area.

⇒ On the Menu Bar, go to Image > Transform > Perspective.

⇓ Two dialog boxes come up when you choose Perspective, asking two questions. Simply click OK.

⇒ After you're finished clicking OK, the picture will be placed in a box with anchor points.

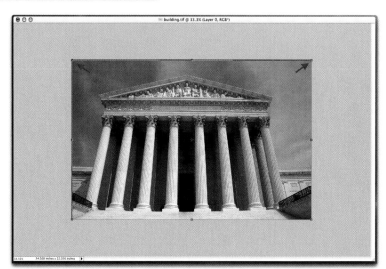

⇒ Next, simply pull out the left anchor point (but you can pull out either the top right or top left) until the building looks much straighter. Press Return.

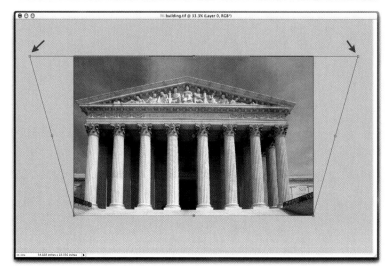

⇒ Here's the straightened shot of the Supreme Court Building. Rather than spending $1,500, I only spent about five minutes in the digital darkroom.

Work Image #17B: Red Rock Canyon and **Work Image #17C: Family Photo** The Transform feature can also be used for another fun and creative effect: placing a picture within an unusually shaped area of another picture. In this example, we'll use a landscape picture I took in Red Rock Canyon, Utah, and a family snapshot (with some type added) that we took at the Grand Canyon.

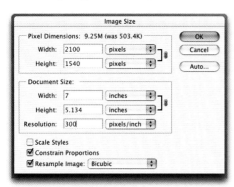

⇑ First, open the two pictures on your monitor. Note: Both images were originally about 5 × 7 inches at 300 PPI.

⇓ Knowing that I wanted the family shot relatively small in the landscape picture, I reduced its size (Image > Resize > Image Size) from about 5 × 7 inches to 2.7 × 2.2 inches. The exact size does not matter, as you'll soon see. However, keeping the resolution the same for both images is extremely important! Why? Because if the resolution is not the same, the number of pixels within one inch in one picture will not be the same number as within an inch in another picture. (See "Must-Know Digital Information" for more information.)

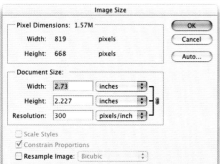

⇒ Clicking on the resized family picture, drag it into the landscape picture using the Move Tool on the Tool Bar. The exact position is not important. The family picture is now placed on a new layer on top of the landscape picture.

Next, select the Rectangular Marquee Tool on the Tool Bar and then select the area around the family picture.

⇓ The next step is to go to the Menu Bar and then to Image > Transform > Distort.

⇓ Now, you can move and distort the image by clicking on and moving any of the anchor points. Here's the effect of moving the left corner anchor point into the left side of the sign.

⇑ Move the family picture into the sign, making sure it covers the sign on the lower layer. Tweak the anchor point to get a perfect match. After the family picture is lined up in the sign below, press Return to activate the changes.

Next, go to Select > Deselect on the Menu Bar to deselect the family photo. Finally, go to Layers > Flatten Layers on the Menu Bar.

We're done! Now it's your turn to have fun transforming your pictures for fun or profit!

Reflections

Mirroring an Image Realistically

LEARN ABOUT

Increase Canvas Size

Rotate an Image

Move Images
between Layers

Outdoors, we marvel when we see a subject beautifully reflected in a lake or pond. The reflection adds another dimension of beauty to a picture.

In Photoshop Elements, creating a natural-looking reflection is easy, with these simple steps.

⇐ **Work Image #18: Cougar on Log** Open this cougar image.

⇒ We want to expand the total working area of our picture. Open the Canvas Size dialog box by going to the Menu Bar and then to Image > Resize > Canvas Size.

⇓ In the Canvas Size box, note the Height. You want to double it, doubling the size of the Canvas vertically. Also note the center

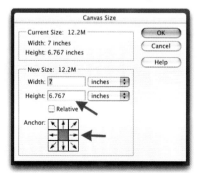

shaded anchor point. Shifting that anchor point to one of the adjacent boxes in the grid increases the Canvas Size in the direction of the arrow in the new box. Leaving the shaded anchor point in the center box increases the canvas size in all directions equally. Because we want a new image with open space below it for reflection, we move the anchor point to the top center box.

⇓ In the Mac OS version of Photoshop Elements, click on the center shaded anchor point (the tones are reversed for Microsoft Windows) and move it up to the

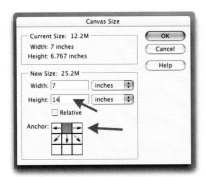

top square. Next, type a number in the Height window that would at least double the Height of the Canvas area. In this example, I rounded it off.

⇑ After clicking OK, the new Canvas Size looks like this. The newly added Canvas area is blank.

Next, use the Rectangular Marquee Tool and carefully select the entire image area of the mountain lion photo. Then go to the Menu Bar and Edit > Copy. Your photo is now copied onto the Clipboard. Next, create a new document by going to the Menu Bar and then to File > New. A new, blank document will be created with the same size and resolution as your copied document.

⇓ To flip the photo, go to the Menu Bar and then to Image > Rotate > Flip Vertical.

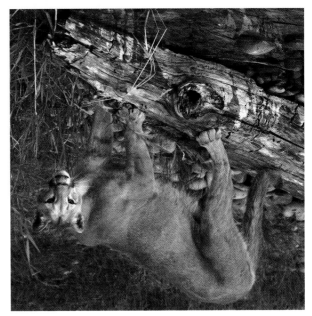

⇑ When you click on and release Flip Vertical, your image will look upside down.

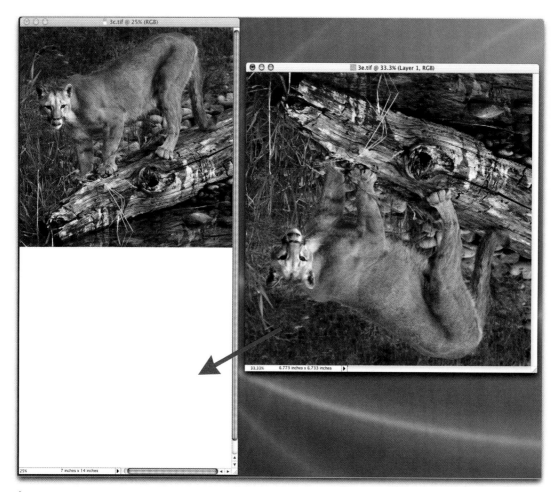

⇑ Next, click on your upside down image. Select the Move Tool and drag your flipped photo into your increased Canvas Size document. Carefully, very carefully, line up the two photos.

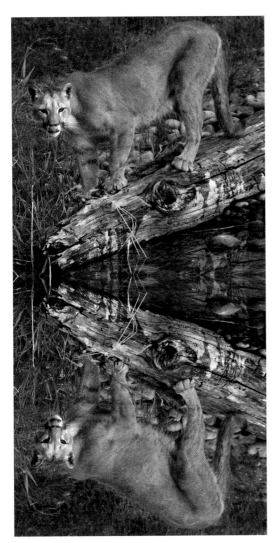

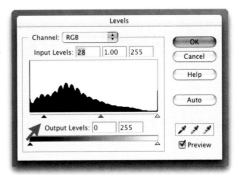

⇒ In real life, the reflecting surface always looks darker than the topside image. So, to create a more realistic reflection image, go to the Menu Bar and then to Enhance > Adjust Brightness/Contrast > Levels. Move the Shadow slider triangle (the one on the left; see my red arrow) to the right until the reflected image is slightly darker than the top image.

↘ Here's the end-result reflection image. Keep in mind that part of the success of any reflection image is starting with a picture that would look natural reflected in water.

⇑ Here's how the two images should look when they are lined up.

⇓ The dragged layer (the upside down image) is automatically selected after it is dragged into the increased Canvas Size document. It's your current working layer—the top layer of a two-layer file (see "Workshop #3: New Layers" for more information).

Type

Make Your Message More Powerful

In Elements, we can add type to our pictures to create flyers, posters, postcards, or Web site images.

⇒ In this lesson, we'll work with the Horizontal Type Tool (the default setting when you click on T in the Tool Bar) and the Vertical Type Tool, which is revealed when you place the cursor over the Type Tool icon and click your mouse.

⇐ **Work Image #19: Yellow Flowers** First, we will use a picture of mysore clockvine blooms, native to India. I found the flower at the New York Botanical Garden in the Bronx. I framed these for a magazine cover by leaving some "dead space" for type at the top of the image.

When using the Type Tool, the type will be the color we set as the foreground color. At the bottom of the Tool Bar in

the first screen shot in this lesson, you'll see that the foreground color is set to black.

⇐ We can change the foreground color by going to the Palette Dock at the top of the monitor, clicking on Swatches, and then clicking on a color. Here I have clicked on Light Yellow. (You can also change the color by using the Color Picker. Read about the Color Picker in "Warm-up #1: A Tour of the Elements Tool Bar.")

⇓ We can even pick the precise color of an area in your picture. Simply select the Eyedropper Tool in the Tool Bar and then move the little Eyedropper into the picture area and click. The color you click on becomes the foreground color.

⇐ Now, select a type size and font from the Menu Bar. Experiment with different type sizes and fonts to see which ones best match the image.

⇓ Now, move your cursor into the image area where you want the type and begin typing. The color, size, and style of type you selected will be inserted where you type. After you are finished typing, you can easily move the type by selecting the Move Tool from the Tool Bar. Our picture is not done yet, so don't worry that the type does not stand out as much as it could. We'll get to that in a moment.

⇒ When you place type in an image, the type is placed on a separate layer. The type is on the top layer and the picture is on the bottom layer.

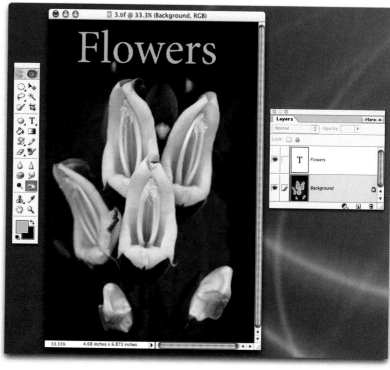

⇓ If we select the bottom layer (flower) by clicking on it and use the Burn Tool to darken the area "below" the word Flowers, the type will stand out better. I also darkened some of the edges of this image to make the yellow flowers more prominent in the scene.

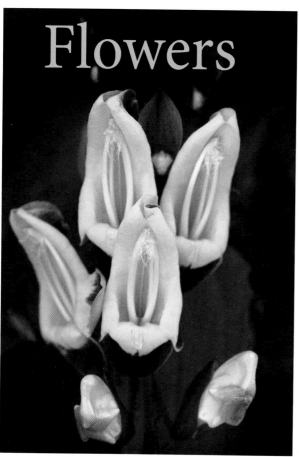

⇓ Keep in mind that you can find space suitable for type by cropping an image. For example, by cropping out all but one bloom, we have space to add the species name and where we photographed it. To keep the white type from being brighter than the filaments of the flower, I faded the type by reducing the Opacity of the type layer from 100 percent to 80 percent.

Thumbergia mysorenis
New York Botanical Garden

Save the Shot

Turn Outtakes into Keepers in the Digital Darkroom

In this workshop, I will share some ideas on how to save "problem" pictures that would otherwise be tossed away.

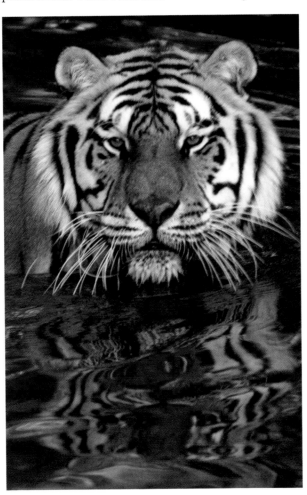

⇐ **Work Image #20A: Tiger in Water** Here is a mistake that we have all made: taking a picture that is out of focus.

⇒ We could try to sharpen the shot in Photoshop Elements using Filter > Sharpen > Unsharp Mask, but that probably would result in a very pixelated picture, because the shot was so soft to begin with.

⇓ Here is an attempt to sharpen the image with Unsharp Mask. The result is too pixelated.

⇒ Because greater sharpening would only have made the picture look worse, I experimented with some filters that soften an image (and work well with images that already are soft). I decided to use the Dry Brush Filter (Filter > Artistic > Dry Brush) at its default setting.

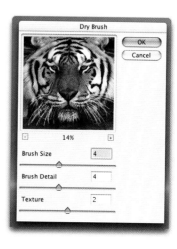

⇓ Now, the picture is still out of focus, but the Dry Brush Filter hides that fact beautifully by adding a soft, artistic touch to the image.

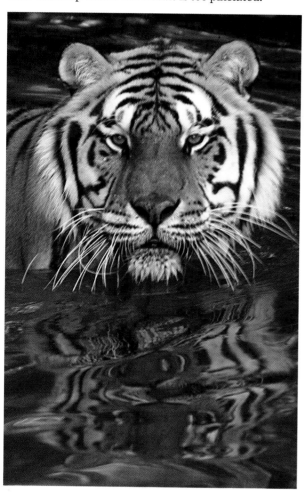

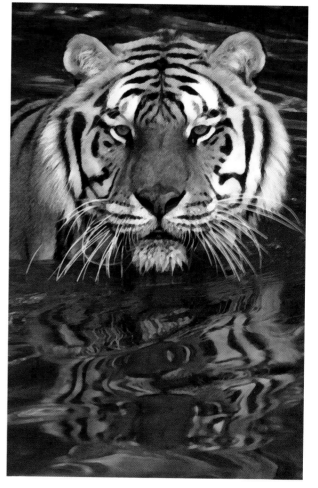

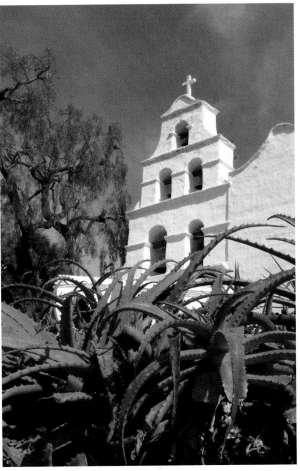

⇑ **Work Image #20B: Mission** Here's another example of how to save a shot. This time, only part of the picture is out of focus. It's a shot of the Mission Basilica San Diego de Alcala, California. The problem is that the foreground is out of focus, because I set the focus point to the center of the frame (the basilica) and used a wide aperture.

⇑ The same scene looks different when the focus point is set one-third into the scene and a smaller aperture is used.

⬊ To "hide" the fact that the plant is out of focus, try applying the Graphic Pen Filter. With the Graphic Pen Filter (Filter > Sketch > Graphic Pen), you can control the Stroke Direction, among other things. I set the Stroke Direction from a pop-up menu to Vertical, because I was looking for a light rain effect. You may want to set a different direction.

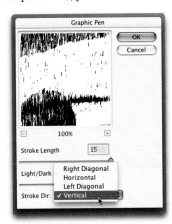

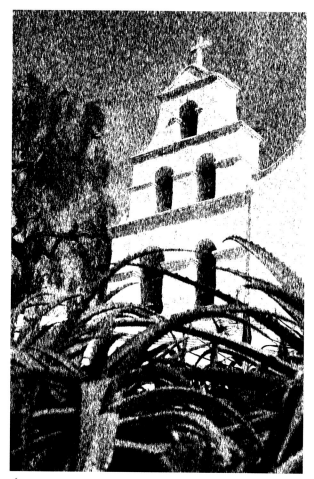

⇑ Here's how the photo looked with what Photoshop Elements suggests for the Graphic Pen Filter. It's creative, but not the effect I was looking for. I wanted a softer effect. In Adobe Photoshop CS, we can fade a filter. In Photoshop Elements we can also fade a filter, but it takes a few more steps.

⇑ Now that's more like it, don't you think? This image shows the result of reducing the Opacity on the top layer (the one with the filter applied). That, in turn, lets the original photo on the bottom layer partially show through. As you'll realize while reading this book, the creative possibilities are endless with Elements. So, let's try another technique.

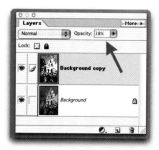

⇐ To be able to fade the filter in Photoshop Elements, first make a duplicate layer of your image by dragging the Background Layer to the Create New Layer icon at the bottom of the Layers palette. Then, apply the filter to the top layer copy. Next, reduce the Opacity of the layer until you are pleased with the result. You can reduce the Opacity by using the slider or by typing in a new percentage.

We can change the color tone of the picture by choosing a new color with the Select Foreground Color Tool (and by using Swatches on the Menu Bar). To change the color on the Select Foreground Color Tool, click on the left box. That will open the Color Picker dialog box. Next, pick your color. I picked a light blue.

Again, I suggest making two layers, so you can fade the effect. In this example, I chose a different Graphic Option: Right Diagonal. I also chose a different Stroke Length and a Different Light/Dark

Balance. Experiment with the settings to get one you like.

Here's the effect of applying the aforementioned filter. Too blue for me.

⇑ As with the first example, I faded the filter for what I think is a more pleasing image.

⇑ Because the picture was substantially softened, I thought soft edges would enhance the overall look of the image. So, I applied the Vignette Selection Effect. (See "Workshop #15: Effects.")

As you can see, we can save a shot using Photoshop Elements. However, please read "Start in Your Camera," in the first part of this book, to see how you can avoid some common mistakes.

Congratulations!

You have read all twenty lessons and practiced with the work images on the CD-ROM. I'd like to say congratulations! You've accomplished a lot, and are on your way to becoming a fine digital image maker.

There is more fun to come. In the next section, you'll find some tips on Plug-ins, which expand your creative horizons when using Elements. I've also included some printing tips, which I trust will help you get inkjet prints that do justice to all your hard work in the digital darkroom.

As you have read, I use both Photoshop CS and Photoshop Elements. Some of you may want to move up to Photoshop CS, Elements's "big brother" someday. For those who don't, as I stated earlier in this book, we can do all the same basic photo adjustments in both programs.

To show you that I practice what I preach, I'd like to leave with you two final before-and-after sets of pictures. I took the pictures in Botswana and enhanced them in Elements—at 30,000 feet on the way back from my photo safari. I would have made exactly the same image adjustments in Photoshop CS.

The next pages contain extra workshops just in case you want more.

See more of my Botswana pictures in *Rick Sammon's Travel and Nature Photography*, also published by W. W. Norton.

PART IV Workshop Extras

Plug In to More Creative Effects

Add Extra Tools to Photoshop Elements

The filters built in to Photoshop Elements offer many creative possibilities for photographers with an artistic flair. To expand the creative options of Adobe Photoshop Elements even further, the program accepts filters compatible with Photoshop—called Plug-ins. Plug-ins are available from various software publishers for a wide variety of specialized uses, from adjusting color to sharpening to adding special effects.

Plug-ins are purchased separately as an Internet download or on a CD-ROM. They are installed in the Plug-in folder in the Photoshop Elements application directory. Once placed there, these third-party tools show up at the bottom of the Photoshop Elements Filters menu.

My favorite Plug-ins are from nik multimedia (www.nikmultimedia.com): nik Color Efex Pro 2.0 and nik Sharpener Pro! Let's take a look at Color Efex Pro 2.0 first.

Here are a just a few before-and-after examples of what the filters can do and some screen shots of the filter windows that show control sliders offering unlimited personal and creative effects.

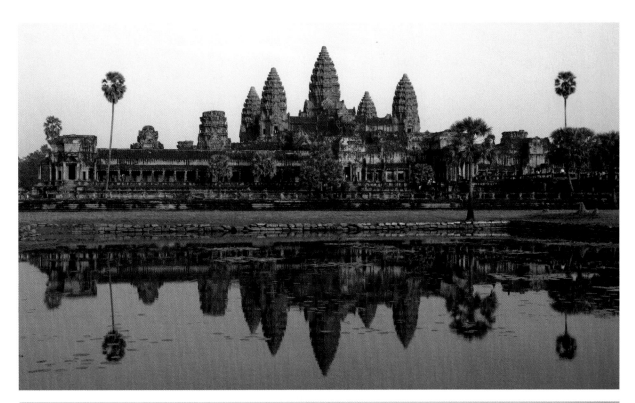

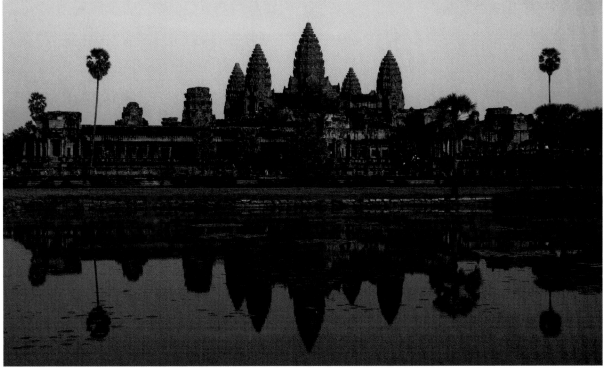

nik's Burnt Sienna adds a creative flair to outdoor scenes by adding a dramatic tone.

Angkor Wat, Cambodia

nik's Gold Reflector creates the effect that a handheld gold reflector was used as the light source.

Young Woman, Vietnam

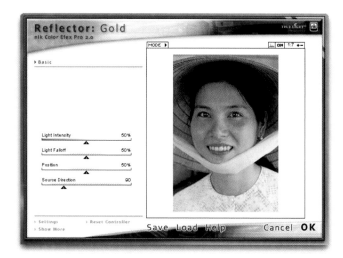

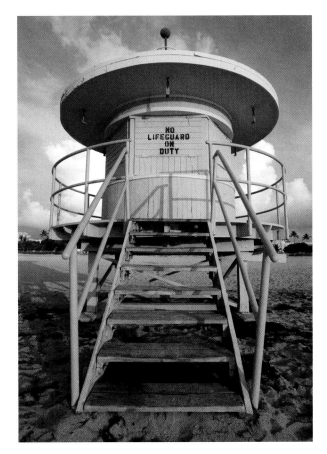

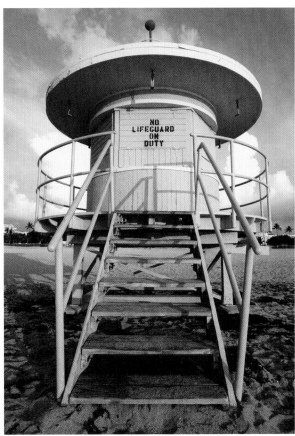

nik's Ink gives photographs a unique, artistic look by selectively coloring a picture.

Lifeguard Stand, South Beach, Florida

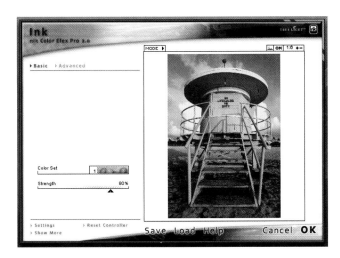

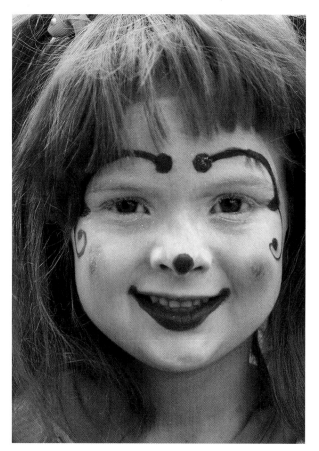
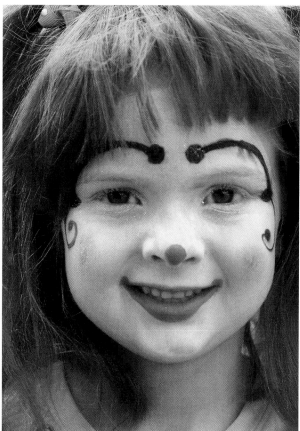

nik's Sunshine brightens dull pictures taken on overcast days and in the shade.

Clown, Sun City Center, Florida

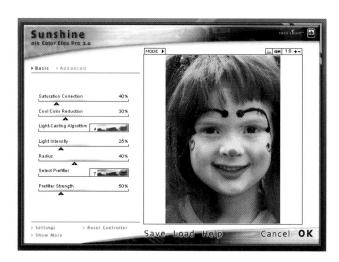

nik's Bi-Color Cool/Warm adds vibrancy and color to outdoor pictures by introducing dramatic color tones.

Brooklyn Bridge, New York City

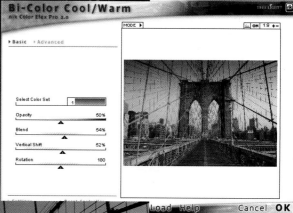

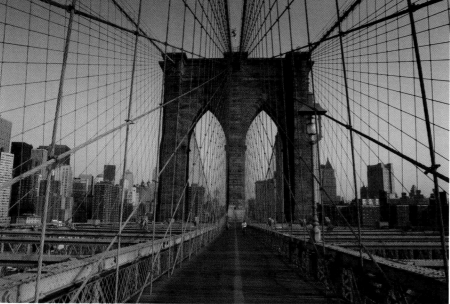

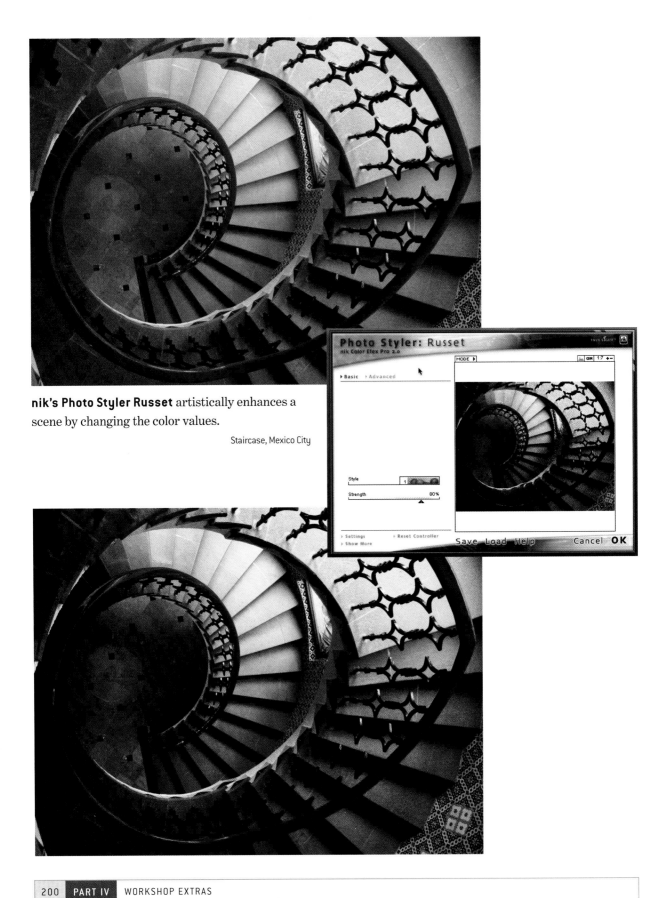

nik's Photo Styler Russet artistically enhances a scene by changing the color values.

Staircase, Mexico City

Photo Styler: Russet
nik Color Efex Pro 2.0

Basic Advanced

Style 1

Strength 80%

Settings Reset Controller

Show More

Save Load Help Cancel **OK**

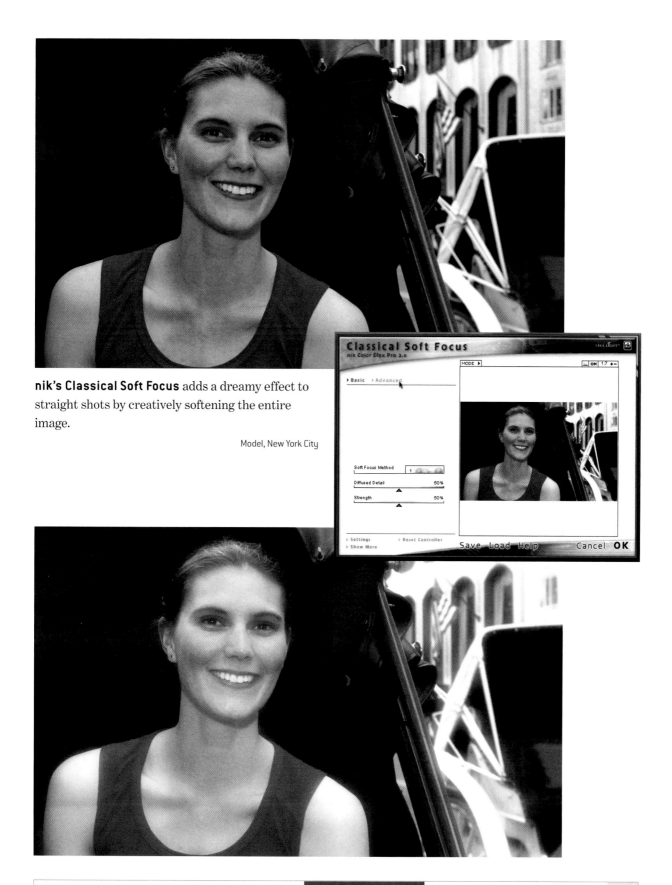

nik's Classical Soft Focus adds a dreamy effect to straight shots by creatively softening the entire image.

Model, New York City

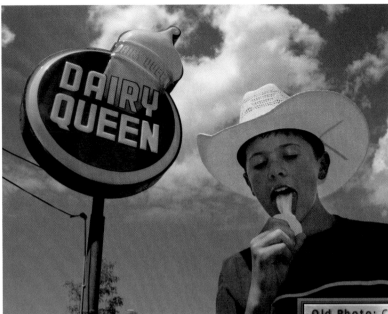

nik's Old Photo creates the impression that a color photograph was taken in yesteryear.

Marco, Arizona Roadside

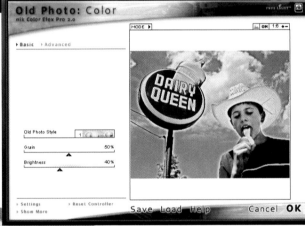

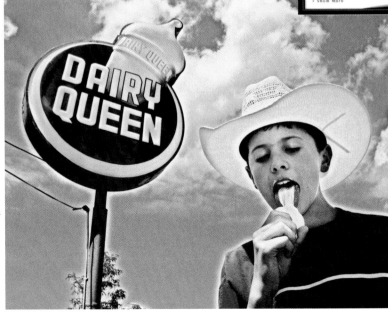

nik Sharpener Pro! makes sharpening easier to understand than when you are using the Sharpening filters in Elements. With this Plug-in, when you are sharpening for an inkjet print, you choose the size of the print, the image source, the image quality, printer, eye distance and a personal profile. The program makes all the sharpening calculations automatically.

Sunset, Rothbury, Michigan

Here's a look at a few of my other favorite Plug-ins.

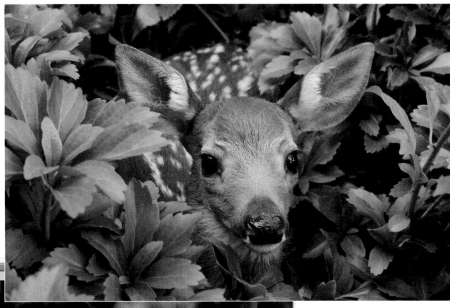

Auto FX DreamSuite (autofx.com) offers countless dreamy effects, including Ghost Type Soft, which you can customize with sliders and controls.

Young White Tail Deer, Croton-on-Hudson, New York

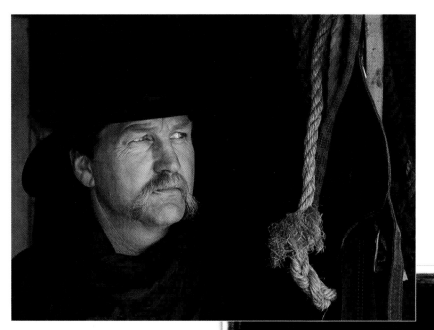

Extensis PhotoFrame

(www.extensis.com) offers dozens of
digital frames that you can
customize to your own liking. Using
a digital frame is a nice way to
"dress up" a photo.

<div align="right">Cowboy, Rothbury, Michigan</div>

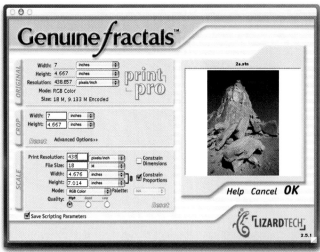

LizardTech Genuine Fractals
(www.lizardtech.com) is a godsend
for photographers who want to
upsize digital files. You save a file as
a Genuine Fractals file and then type
in a new file size or image
dimensions. Genuine Fractals works
up to a point. For example, you can't
convert a 4 × 6-inch print at 72 DPI
to a 30 × 14-inch print at 300 DPI.
(Note: the Genuine Fractals Plug-in
shows up in the Save As menu and
not under Filter.)

Enlargements of landscape
photographs need to be very sharp.
Genuine Fractals can help increase
the image size of smaller files for
tack-sharp prints.

Print Your Picture Successfully

Sharing your Images on Paper

LEARN ABOUT

Printers

Inks

Papers

Editing our pictures in Photoshop Elements is only part of the digital darkroom fun. Printing is another creative step in the process.

⇊ Today, we can make prints on our desktop printers and even while on the road with battery-powered printers. However, getting a perfect print from a desktop printer is not always as easy as clicking the Print button on your printer's software menu.

Even if we take the time needed to calibrate our monitor and work under consistent lighting conditions, a print can still be off-color, too light or too dark, or have too little or too much contrast. That's because a new or different type of paper, or a change in room temperature or humidity, can affect the way a finished print looks. So can clogged inkjet heads and low ink levels.

Enter the printer's software driver. It's designed to help you get the best possible print by offering additional creative and correction controls.

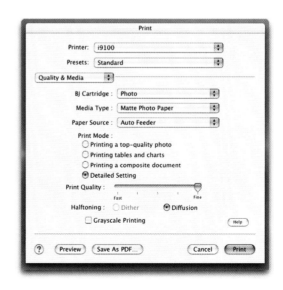

⇒ The software lets us choose the correct Media Type, which is of the utmost importance. Media refers to the kind of material on which we want to print our image. In this screen shot, I have chosen Matte Photo Paper because that was the type of paper I was using.

If we choose the wrong Media Type, the wrong amount of ink will be deposited on the paper. The print may look blotchy, thin, and off-color. It may have streaks, gaps, or lines. So, be sure to match the Media Type to your choice of paper, unless you want an intentionally unpredictable result (which may be artistic in its own right).

The software for a high-end photo-quality printer offers additional options for controlling print quality. We may select settings based on the subject of the picture. Here I chose Sepia because I was printing a color picture of a Native American I photographed on a mountaintop in Montana, and I wanted to give it an "old-time" look.

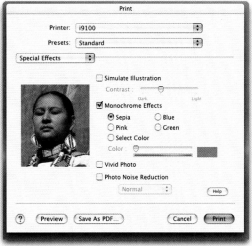

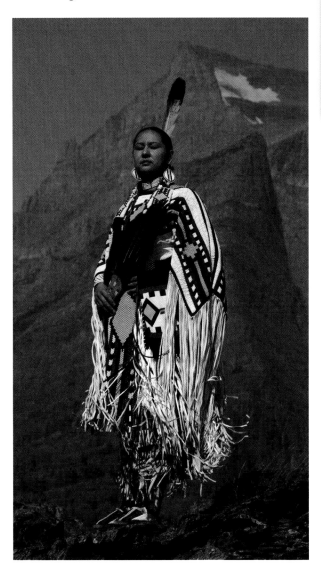

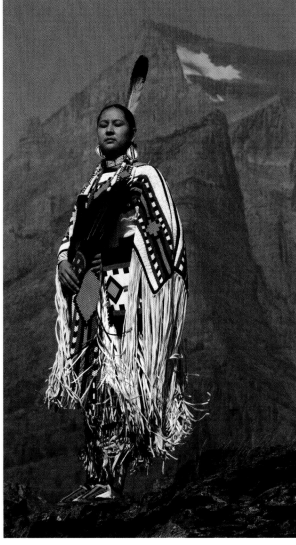

The software that is provided with most high-end printers also offers fine-tuning of the color of an image. For my lighthouse picture, taken near Rockport, Maine, I used the printer's software to increase the cyan and decrease the yellow, and then to darken the image to create, perhaps, the impression that the picture was taken in the light of a full moon.

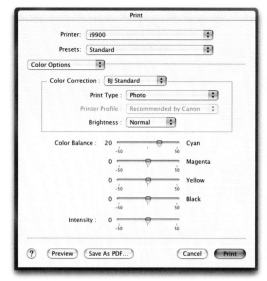 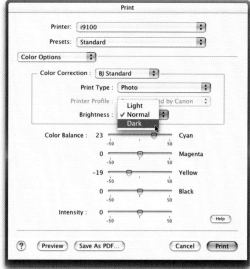

This before-and-after set of images shows the effect of adjusting color and brightness with the printer's software.

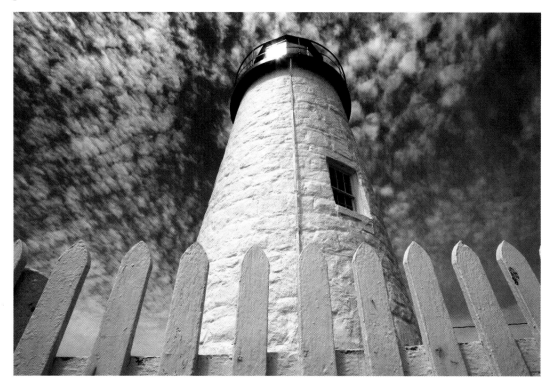

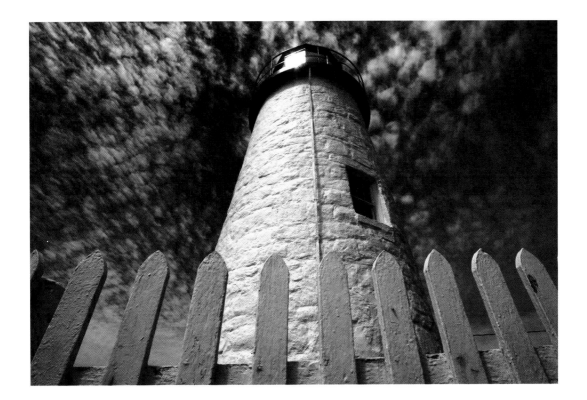

Even when you make a print that initially looks great, it's possible that you may not be happy with it later because of metamerism. Metamerism affects prints that are made with pigment-based inks. It makes prints change appearance depending on the color of the light source under which they are viewed. So, a print made at night in your darkened den may look different in your sunny office or living room. Newer, high-end printers with pigmented ink, such as UltraChrome by Epson, produce prints that have a reduced amount of metamerism. Unfortunately, the effect will never completely disappear with the current crop of pigmented inks.

Advanced Printing

LEARN ABOUT

Calibration

Resolution

Inks

At the beginning of the previous lesson I said that calibrating your printer and monitor may not solve all your problems. However, if you are serious about getting a print that matches the image on your screen, you really should take the time to calibrate properly. If you don't, the printed image may be "way off" from your original file.

That said, today's LCD and flat screen monitors (especially the Apple 23-inch Cinema Display, which I use), do not need as much calibration as early CRT monitors. So, for the serious printer, here's a quick look at monitor calibration.

Calibration can be a daunting subject. Entire books have been written on it, and if you do a Google search, you'll find more than 334,000 hits. Although calibration can be helpful, there are other options for getting a good print, such as using your printer's software.

Monitor calibration systems, which include a calibration unit and dedicated software, are designed for photographers who are serious about getting accurate color in their prints.

⇒ Several different calibration systems, consisting of a calibration unit, which looks like a mouse and rests on your monitor, and software, are available. You place the calibration unit on your monitor and follow the on-screen calibration steps in the system's software. This process usually takes a few minutes.

Digital Light & Color (www.dl-c.com) offers Profile Mechanic, GretagMacbeth (www.gretagmacbeth.com) offers the Eye-One Display, Monaco offers the MonacoOPTIX XR (www.monacosys.com), and Pantone (www.pantone.com) offers the ColorVision Spyder. These companies (except for Digital Light & Color) also offer calibration systems for printers and scanners.

Looking for a new printer to display and share your digital darkroom creations? Here are a few features to consider.

Printer image resolution. Resolution is an often-debated topic when choosing a printer. Understanding resolution is important. Serious photographers want to get the best possible prints from their desktop printer. So, if you are new to digital printing, you might think that if you have a printer with a maximum advertised resolution of 1440 DPI (dots per inch), you should select that resolution when scanning a picture or when determining the file size of a picture, and print all your pictures at that resolution.

However, doing so will create a huge file that will take an extremely long time to print and take up additional megabytes of hard drive space. Such a huge file is not necessary to get a great print. Here is why.

Printer resolutions are measured in DPI. But a printer's DPI count is not the total number of dots placed side-by-side in an inch. Rather, it is the total number of dots that can be placed in a square inch, often on top of one another. So, if you have a six-color inkjet printer, it's not impossible to have six different colors dropped in the same spot. A 1440 DPI printer would give us a real resolution of 240 DPI.

Most of my fellow professional photographer friends use that 300 DPI setting when making inkjet prints, and are pleased with their results. For example, when I make an 11 × 14-inch print, I set the image resolution in my imaging software to 300 DPI.

⇒ If you use a much lower resolution, your pictures will become pixelated, more noticeable as the pixel number decreases and the print size increases. These two pictures illustrate how an 8 × 10-inch print looks when printed at 300 DPI (top; extremely good) and at 72 DPI (bottom; very pixelated).

Ink tanks or cartridges. Early inkjet printers had two ink tanks: one for black ink and one for color ink (usually containing cyan, magenta, and yellow). Desktop printers with this two-tank, four-ink system are still available today, and will produce good results.

The trend for serious image makers is to choose a printer that has individual ink tanks, which has long been the standard for large-format printers used in the graphic arts industry.

⇒ Today's top-of-the-line printers have six, seven, or even eight ink tanks, the last as seen in the Canon i9900's ink tank cassette.

There are two major advantages to using individual ink tanks. The first is that you have better control over color and black-and-white prints. (If you are interested in making art-quality black-and-white prints, look for a printer that also includes a Light Black ink tank. This additional black ink tank will produce superior midtones and grays in the finished print.) The second benefit of individual ink tanks is that you don't have to replace an entire ink cartridge if only one color runs out, ultimately saving you some money. Usually, as the number of ink tanks increases, so does the cost of the printer.

Types of ink. There are two types of ink for desktop printers: dye and pigment.

Printers with dye-based inks produce prints with more vivid colors and saturation. However, dyes, especially yellow and magenta, can become unstable over time. If and when they fade, a dye-based ink print may take on a cyan cast as the magenta dye fades.

Printers with pigment-based inks produce a print that will last longer (when displayed under the same conditions) than a print made with a dye-based printer. The tradeoff is that prints made with pigment inks usually don't have the same vivid color quality.

The archival quality of inkjet prints has greatly improved over the years. To keep up to date on archival issues, for both inkjet paper and inks, see the independent test site of the Wilhelm Research Institute: www.wilhelm-research.com.

In addition to the inks provided by printer manufacturers, third-party and generic inks and ink-cartridge refills are available. You may be able to save some money by using other kinds of inks. Some may even approach archival quality. But before you insert off-brand inks into your printer, consider all the advantages and disadvantages. Printer manufacturers don't recommend these inks, because they want you to buy their inks. In addition, using an off-brand ink or refill may void the printer's warranty (as will using off-brand paper).

Maximum print size. Basic desktop printers produce 8 1/2 × 11-inch prints. More sophisticated printers can produce 11 × 14-inch, 13 × 19-inch, and even larger prints on flat paper. Some printers accept roll paper for making panoramic prints. In choosing a printer, consider the maximum size print that you think you'll ever make.

Image coverage. Some printers let you print a borderless picture—that is, printed right to the very edge of the paper. If you like borderless prints, make sure you select a printer with that option.

Noise level. Many photographers like to work when it is quiet, or with soft music playing in the background. (Not all creative types do; Stephen King plays loud heavy metal while writing his books.) If you like to work in a quiet environment, look into the printer's noise level. Some are noticeably noisier than others.

Printing speed. For many photographers, a printer's speed is important. If you are a Type A personality, like me, be sure to compare printer speeds, too. Sometimes, speed affects image quality, especially when higher resolution settings are selected, but not always.

Versatility. Most desktop printers connect to computers via a USB or FireWire (IEEE 1394) cable. Some printers also offer built-in memory card readers, on-printer image controls, and even a small LCD screen for previewing a picture. With this type of printer, you don't even need a computer to make a print, because your image can move directly from the camera's memory to the printer. But if you are serious about fine-tuning the color, contrast, and brightness of a print, you will want to improve those with your computer, rather than relying on the elementary printer controls.

Here is one final tip on printing. It may sound simple, but it's important. To get a good print, you must start out with an image with good color, contrast, image resolution, detail, and, of course, an interesting subject. Before you press the Print button, make sure you have done everything within your power (and within the power of Elements) to produce the best possible on-screen image.

Acknowledgments

More than a few dedicated and talented individuals, friends, and colleagues helped me with the production of this book. So, although my name is on the front cover, this book was really the combined effort of a team. Here's a look at the team roster.

George Martin, the musical arranger for the Beatles, and often called the "Fifth Beatle," had nothing to do with this book. But as John, Paul, George, and Ringo often acknowledged, George Martin was a key player in the success of the Fab Four. He fine-tuned the group's sound, making each song unique, and always remained behind the scenes. So why am I talking about the "Fifth Beatle"? Well, Leo Wiegman, my editor at W. W. Norton & Company, helped me orchestrate this book. He reminds me of Mr. Martin, and of how one person can have such a positive influence over a project, be it a book or a record album. Much like Mr. Martin, Leo was happy to stay behind the scenes. Leo listened to my original compositions of words and pictures, and transformed them into enjoyable chapters and lessons. He worked eight days a week on my manuscript, using all his editing and photo skills to make this book the best it could be. So, Leo, from me to you, thank you!

Several other members of the W. W. Norton & Company team also helped transform my pictures, words, and screen shots into an easy-to-follow book. They include: Carole Desnoes, Julia Druskin, Ingsu Liu, Sarah Mann, Seamas O'Brien, Nancy Palmquist, Don Rifkin, Bill Rusin, Elizabeth Van Houten, and Rubina Yeh.

Having a little help from my friends was also a key element in the production of this book.

Julieanne Kost, Adobe evangelist, inspired me to get into Photoshop in 1999. Before that, I'd just launch Photoshop and stare at the Tool Bar and Menu Bar and wonder what to do. During a short presentation at FOTOfusion (www.fotofusion.org), Julieanne showed me and the other attendees the power of Photoshop, and that you don't have to have a degree in rocket science to work and play in the digital darkroom.

Addy Roff at Adobe also gets a big thank you from me. Addy has given me the opportunity to share my Elements and Photoshop CD tips and tricks with hundreds of dedicated enthusiasts around the country.

My dad, Robert M. Sammon, Sr., despite the fact that he has macular degeneration and has a hard time reading, edited my text before I submitted it to Leo. Even at eighty-six, he's still one of the best editors I know.

My son, Marco, was also a big help, posing for pictures even when I knew he'd rather be playing video games.

Joe Farace, my technical editor, was always there for me. Joe was technical editor for my *Complete Guide to Digital Photography* (also published by W. W. Norton & Company). He's a good friend and a talented individual.

Rob Sheppard, who supplied the glossary and who wrote the foreword for this book, has been my friend and advisor for almost eight years. I've learned a lot from Rob in his lectures and workshops.

My photo workshop students were, and always are, a tremendous inspiration. Many showed me new digital darkroom techniques, some of which I use in this book. During my workshops, I found an old Zen saying to be true: "The teacher learns from the student."

And speaking of pictures, Dave Metz, Steve Inglima, and Peter Tvarkunas at Canon have been ardent supporters of my work and of my photography seminars. The Canon digital SLRs, lenses, and accessories that I use helped me capture the finest possible pictures for this book.

Other friends in the digital imaging industry who have helped in one way or another include Monroe Gordon of WYNIT; Tanya Chuang, Mike Wong, and Jim Gall of SanDisk; Ed Sanchez and Mike Slater at nik multimedia; the late Dean Collins and Gary and David Burns at Software-Cinema; George Schaub, editorial director of *Shutterbug* magazine; Scott Kelby and Chris Main of *Layers* magazine; Richard Rabinowitz, Russell Hart, Burt Keppler, and John Owens of *Popular Photography and Imaging* magazine; and Lauren Wendel of *Photo District News*.

All photographs in this book were taken with Canon cameras and recorded on SanDisk CompactFlash memory cards.

Glossary

At the Temple of the Dawn, Bangkok, Thailand

Moose Peterson

By Rob Sheppard

Editor, *Outdoor Photographer* and *PCPhoto* magazines

Adjust Backlighting: unique Photoshop Elements control that lets you darken bright areas with minimal effect on dark sections of image.

Adjustment Layer: a layer without pixels that carries instructions to affect what is seen on any layer under it; it allows adjustments to be changed at any time since the original changes are not permanent.

Background Color: one of two colors that are always available for use and show up at the bottom of the Tool palette; the background color is the one at the bottom, "behind" the other; it can be changed by double-clicking to bring up the Color Picker.

Batch Processing: a way of making a single type of change, such as new file type or image size, to a group or "batch" of image files all at once.

Blur Tool: a brush-based tool that lets you literally brush on a slight blur to the image.

Brush Tool: the basics of the Brush Tool apply to all tools that are brush based; this tool can be selected for brushing on color or tone in precise

ways by controlling the size, the softness, and the opacity (or intensity) of the brush.

Burn Tool: a brush-based tool that darkens areas that you drag your cursor over; works best when used at low levels of exposure.

Clear/Purge: two names for the same thing, depending on version; this allows you to remove things being held in memory, purging or clearing your computer's RAM of them; this will often speed up processing in the program.

Color Picker: a color palette that allows you to pick colors based on hue (the actual color), saturation (the intensity), and tonal value (from black to white); it appears when you double-click on the foreground or background colors.

Color Variations: an intuitive control that shows you variations of color effects on your photo; you select what you like by clicking on the color variations that look best to you.

Clone Stamp Tool: the "cloning" tool; this brush-based tool lets you copy small areas from one spot and clone them (paste them) over other places in the image; often used to cover up or fix problems or defects in the photo.

Copy: the same command in all software that uses it. This copies whatever is selected (such as a layer or a selection of it), leaves the original, and makes a new copy on a separate layer.

Cut: like Copy, the same command in all software that uses it. This copies whatever is selected (such as a layer or a selection of it) but removes or cuts the original and places this removed segment on a separate layer.

Dodge Tool: this brush-based tool acts like the traditional dodging tool in a darkroom—it lightens whatever it moves over. Highly sensitive, it is usually used at low settings, and like all brush tools, needs to have a size selected.

Elliptical Marquee Tool: a shaped selection tool that allows you to create a selection based on an ellipse or a circle (hold down Shift key for circle).

Eraser Tool: this tool removes pixels from the image, so it takes out pieces of an image permanently; a brush-based tool, it can be set to varied sizes and opacities (strengths).

Eyedropper Tool: an image-sampler tool; alone, it samples colors and selects them for the foreground color; it is also part of several adjustment windows, such as Levels, and is used for specific image-sampling purposes ranging from black or white levels to colors.

Feather: a blending of a selection edge so a selection is "feathered" or blended into the areas around it.

Fill Flash: a unique adjustment in the Enhance menu that allows you to lighten shadows without lightening bright areas.

Filter: a special adjustment built into the program that

makes a unique change to the image ranging from sharpening to special effects such as a watercolor painting look.

Foreground Color: one of two colors that are always available for use and show up at the bottom of the Tool palette; the foreground color is the one at the top, "in front of" the other; it can be changed by using the Eyedropper Tool to select a color in the photo or double-clicking to bring up the Color Picker.

Gradient Tool: a tool that blends the foreground and background colors together across an image, a selected area, or in a layer mask.

Graphics tablet and pen: a way of controlling your cursor's movement and actions by using an electronic tablet that senses where its graphic pen is moving; an alternative to the mouse.

Hints or How To: this is a special palette (that changed names in different versions of Elements) that includes specific how-to hints on doing many important adjustments in Photoshop Elements.

Histogram: this is a very important tool for adjusting a photo that looks intimidating at first; it is a graph of pixels at different brightness levels in the photo, with black represented at the left, white at the right, and gray in-between.

Hue: the actual color of a color.

Lasso Tool: a freehand selection tool that follows exactly where your cursor goes.

Layer Mask: a special part of an adjustment layer that allows you to turn the layer effects on and off by painting in white or black respectively.

Layer Styles: unique adjustments added to a layer from the Styles and Effects palette; very useful for text and shapes, doing such things as embossing them or adding a drop shadow.

Levels: key tonal adjustment tool for Elements; this uses a histogram and three sliders under it to affect the image: the left is for dark areas, the middle for middle tones, and the right for bright areas.

Magic Wand: an automated selection tool that allows you to click on an area, and everything around that point is selected depending on the sensitivity setting (tolerance); Contiguous selects areas connected to each other, while unchecking Contiguous will select everything in the photo within the defined tolerance of the tool.

Magnetic Lasso Tool: an "automated" freehand selection tool; this tool will find an edge to select along for you, but it does need some contrast to an edge to be able to do this (you can also set its sensitivity in edge contrast and width).

Mouse: a piece of hardware for controlling your cursor's

movement and actions by using a handheld electronic device that senses movement.

Paint Bucket Tool: a mass filling tool; with this chosen, your cursor will "pour in" the foreground color wherever you click; you can limit the filled area by using a selection.

Paste: the same command in all software that uses it. This places or "pastes" whatever is in memory that was cut or copied onto a new place on the image onto a separate layer. **Paste Into** places or pastes the cut or copied pixels into a selection.

Photomerge: a unique panoramic tool that allows you to take multiple images across a scene, then automatically stitch them together into a single panoramic shot.

Polygonal Lasso Tool: a highly controllable freehand selection tool that follows your cursor but only sets down selection points when you click on a spot in the photo.

Print Layouts / Print Multiple Photos: an automated menu selection (under File—name has changed with different versions) that allows you to print more than one photo per page (use Picture Package choice).

Purge/Clear: two names for the same thing, depending on version; this allows you to remove things being held in memory, purging or clearing your computer's RAM of them; this will often speed up processing in the program.

Quick Fix: a simplification of the Photoshop Elements interface so that you can access key image adjustments quickly.

Recipes: a name for a palette for earlier versions of Photoshop Elements; see **Hints or How To**.

Rectangular Marquee Tool: a shaped selection tool that allows you to create a selection based on a rectangle or square (hold down Shift key for square).

Saturation: the amount of brilliance or intensity of a color; how colorful or dull a color is.

Selection Brush Tool: a tool unique to Photoshop Elements that allows you to literally paint a selection with its brush-based attributes.

Selection: a way of isolating part of an image so it can be adjusted, changed, copied, or otherwise changed without affecting any other part of the image.

Sharpen Tool: a brush-based tool that allows you to selectively sharpen parts of an image by moving your cursor over them (holding down the button on the mouse or graphics pen).

Smart Fix: what Photoshop Elements 3.0 calls the Quick Fix features of Elements 2.0.

Smudge Tool: a brush-based tool that lets you push pixels around, "smudging" them like you would smudge a crayon's stroke; a way of blending edges of an image.

Sponge Tool: a brush-based tool that affects saturation or desaturation (you choose) of colors as you move the cursor over them (with the mouse or graphics pen active).

Undo History: a chart of the actions taken on your photo, its history, that allows you to see what you've done and back up to earlier actions.

Unsharp Mask: the name is misleading (it is based on an old commercial printing term); it is a highly controllable adjustment used for sharpening an image and includes three settings: Amount, Radius, and Threshold.

Zoom Tool: this tool looks like a magnifier because that is exactly what it does—magnify the image; click on the photo and it enlarges from that point; hold down the Alt or Option key while clicking, and the tool causes the photo to get smaller, zooming out from the image.

Index

About the Author

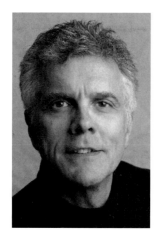

Author and photographer Rick Sammon's recent *Complete Guide to Digital Photography* is a "must have" among digital photography enthusiasts. Rick is host of the Digital Photography Workshop on the Do It Yourself (DIY) network and the guest host of the Photo Safari on the Outdoor Life Network. Rick's recent nature photography books include *Flying Flowers*, on live butterflies in natural habitats, and *Secrets of the Coral Reefs*, on the beauty of life in these ecosystems. Rick has also produced two interactive training CDs, "Photoshop® CS Makeovers" and "Photoshop® CS for the Outdoor & Travel Photographer." Rick lives in New York State's Hudson Valley. www.ricksammon.com